EASY ACRYLIC PAINTING

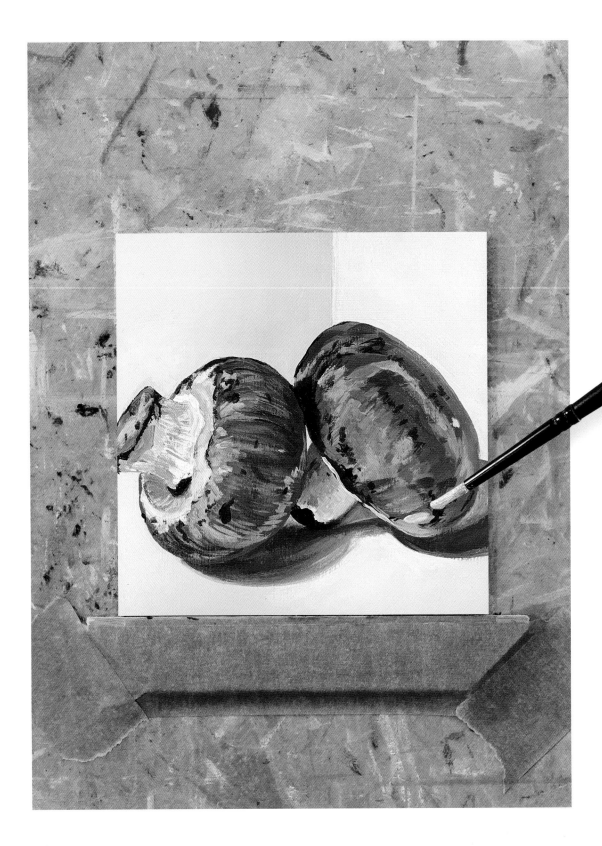

EASY ACRYLIC PAINTING

BEGINNER TUTORIALS FOR SMALL STILL LIFES

JENNIFER FUNNELL

SEARCH PRESS

A QUARTO BOOK

This edition published in 2024 by
Search Press
Wellwood
North Farm Road
Tunbridge Wells
Kent TN2 3DR

ISBN: 978-1-80092-221-1
ebook ISBN: 978-1-80093-203-6

Conceived, edited and designed by
Quarto Publishing, an imprint of
The Quarto Group
1 Triptych Place
London SE1 9SH
www.quarto.com

QUAR: 421977

Assistant editor: Ella Whiting
Managing editor: Lesley Henderson
Designer: Hugh Schermuly
Art director: Martina Calvio
Publisher: Lorraine Dickey

Printed in China

Bookmarked Hub
For further ideas and inspiration, and to
join our free online community, visit
www.bookmarkedhub.com

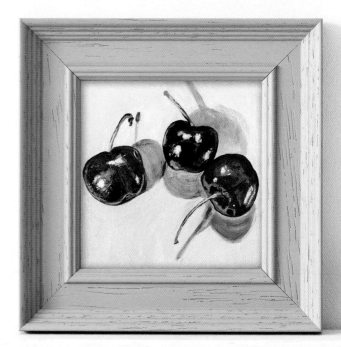

CONTENTS

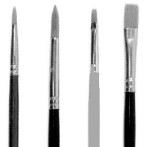

Meet Jennifer

I have been creating art for as long as I can remember. It was in high school that I first fell in love with acrylic painting, and also around this time that I decided I wanted to be an art teacher. I attended Kendall College of Art and Design in Grand Rapids, Michigan, and received a BFA in art education. I thoroughly enjoyed my time in art school, and it fueled my passion for the creative process. I loved getting to experiment with a wide variety of materials and artistic processes. I continued to return to acrylic painting even after practicing with oils and watercolors. Acrylic paint allowed me to achieve the results I was looking for: a slightly stylized version of reality. The opaque coverage is fun to layer but the ability to add mediums to thin the paint allows you to explore many different styles.

I began my teaching career in 2009, working primarily with secondary students. Teaching has allowed me to hone the skill of scaffolding, breaking down the process step by step, which makes it feel manageable. This book is designed for the complete beginner with an emphasis on the acrylic painting process. The steps provided in the book will guide beginners through the process, while offering suggestions for making the piece your own. Acrylic paint can be challenging, but it is also highly forgiving due to its fast drying time and opaque coverage.

In this book we will paint singular objects so that we can focus on the painting process without feeling overwhelmed by too many subjects at a time. As you gain confidence, feel free to add additional objects to the composition.

The paintings in this book are small (5 x 5 in/13 x 13cm), so you don't need a large work area. They can be completed in a singular session or over a period of days. Sometimes taking a break now and again can be helpful. The paintings are completed on a gessoed wooden panel but feel free to substitute stretched canvas or another surface if you prefer. Acrylic is a very versatile medium and adheres to many different surfaces.

If you are new to acrylic painting, I suggest that you read the first part of the book (pages 8–39) first, as it is extremely helpful to gain an understanding of the basics—materials, techniques, colors, and how to set up a workspace—before you begin.

Remember that starting something new requires an open mind and a commitment to practice. Continue to show up, put in the time, and you will see results. I often learn through trial and error; mistakes are a valuable part of the learning process. Allow yourself to dive in, experiment, and have fun!

Happy painting,

Jennifer

About this book

Before beginning your first painting, read through chapters 1–4 to familiarize yourself with the basics. Each project in the book has its own set of unique challenges, but you'll find that as you work through them, you'll pick up new skills that you can transfer to your next painting. You may work through the book in any order.

A list of paint colors is included with each project. You can easily substitute some of these colors for others depending on the paints that you have. Keep in mind that acrylic paint dries quickly: see pages 38–39 for tips on setting up your palette.

Here you will find details on the set-up used for each still life. Each includes a directional light source, highlighted in the book. You can always experiment with lighting and try different varieties, such as warm lighting or cool lighting.

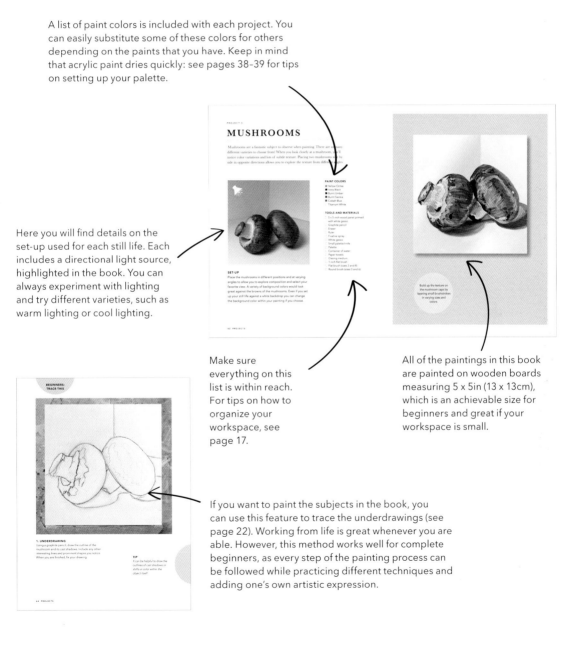

Make sure everything on this list is within reach. For tips on how to organize your workspace, see page 17.

All of the paintings in this book are painted on wooden boards measuring 5 x 5in (13 x 13cm), which is an achievable size for beginners and great if your workspace is small.

If you want to paint the subjects in the book, you can use this feature to trace the underdrawings (see page 22). Working from life is great whenever you are able. However, this method works well for complete beginners, as every step of the painting process can be followed while practicing different techniques and adding one's own artistic expression.

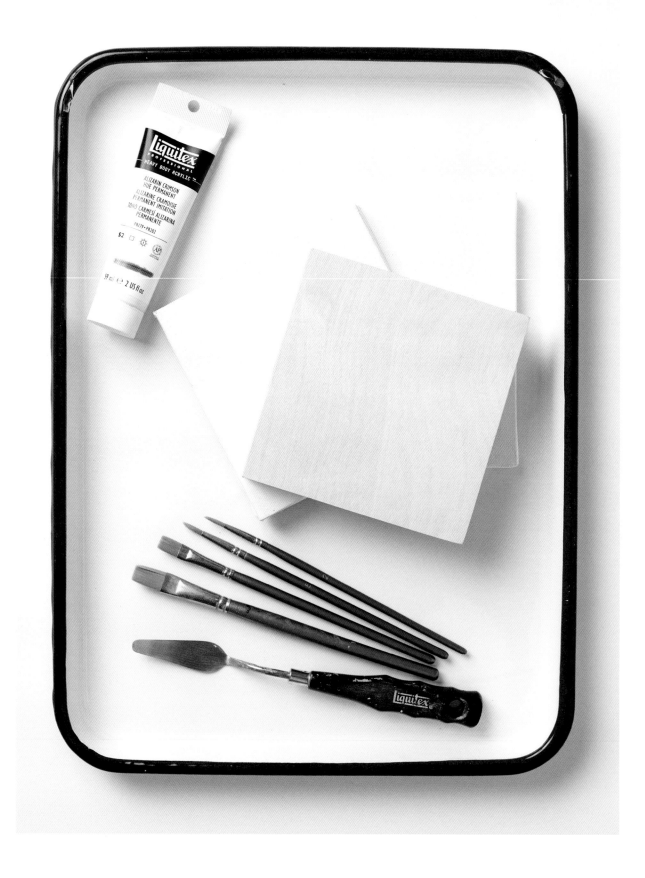

PAINT, SUPPLIES, WORKSPACE

If you have never used acrylic paints before, this chapter will help to demystify which paints, brushes, and other tools are essential for the projects in the book. Here you will also find advice on setting up a workspace.

What is acrylic paint?

Water-based acrylic paint is composed of pigment particles dispersed in an acrylic polymer emulsion. There are three main components in any acrylic paint: pigment, binder, and vehicle.

1. Pigments are granular solids which give paint its color. They are milled to a tiny particle size and do not dissolve, but remain suspended in the paint. Pigments can be organic, inorganic, natural, and synthetic. They have little or no affinity for the surface to which they are applied.

2. A binder is the substance that keeps pigment in place after the paint dries. Acrylic paint has acrylic polymer as its binder, which forms a film after the water has evaporated.

3. The vehicle refers to the part of the paint that carries the pigment and binder. Water is the vehicle for water-based acrylic and when combined with the binder, it creates a polymer emulsion. Once the water leaves the system via evaporation or absorption, the paint dries, creating a stable, clear polymer film full of trapped colored pigment particles.

Paint choices

The paints listed below form the basic palette for the projects in this book. Many of these colors can be substituted for others that you may already have.

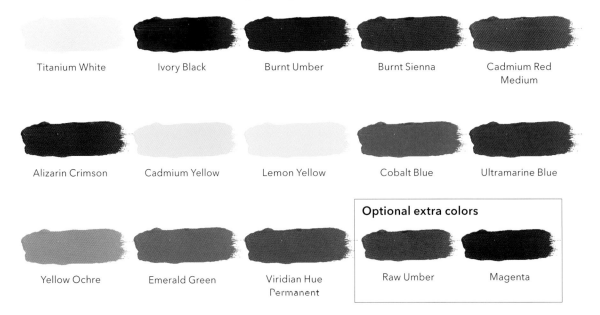

Titanium White Ivory Black Burnt Umber Burnt Sienna Cadmium Red Medium

Alizarin Crimson Cadmium Yellow Lemon Yellow Cobalt Blue Ultramarine Blue

Yellow Ochre Emerald Green Viridian Hue Permanent

Optional extra colors

Raw Umber Magenta

ARTIST-QUALITY AND STUDENT-QUALITY PAINTS

Lightfastness is a property of a colorant such as dye or pigment that describes its resistance to fading when exposed to light.

The lower the series number (for example, "Series 1"), the cheaper the paint will be. As the number goes higher, so will the price.

Opacity refers to whether or not you are able to to see through the paint. The more opaque a color is, the more solid it is. Semi-opaque paints may need multiple coats to increase the opacity. Diluting paint with glazing medium or water will result in the paint being more transparent and less opaque.

Thinning

Acrylics should never be thinned with more than 25 percent water. Too much water will upset the balance and spread the acrylic polymer too thinly, so the molecules can't reconnect properly to form a stable film. Instead, you should dilute with an acrylic medium, which is essentially the same as the paint but without the color pigment. This way, you are adding more of the acrylic/water emulsion to keep the formula and film stable.

Note: Most paint companies have a recommended maximum amount of water that you can safely add to the acrylic paint before it will break down the binder.

Student-Quality

- Less paint coverage
- More affordable price range
- Greater color shift
- Good for large-scale painting and under-painting

Color: Liquitex Basics Cadmium Red Medium Hue
Pigment: PR170, PR9, Series 1
Opacity: Semi-opaque
Lightfastness: Very Good

Artist-Quality

- Highest pigment levels
- Varied price range
- Widest choice of color
- Limited color shift

Color: Liquitex Professional Heavy Body 154 Cadmium Red Medium
Pigment: PR108, Series 5
Opacity: Opaque
Lightfastness: Excellent

When you see "hue" written on a paint tube it means imitation— not a pure Cad red pigment but a combination of cheaper available reds to make a color very close, so it's never going to have the color saturation that an artist-grade paint will have. Pigments that are manufactured to resemble historical colors can also be called "hue."

TIP

Acrylic paints are usually darker in tone as they dry, making color matching difficult. Artists have to remember to allow for this when mixing wet colors. It's known as color shift and is due to the binder changing from white to transparent as it dries.

ACRYLIC PAINT BODIES

The choice between heavy body, soft body, and fluid acrylics will depend on the type of artwork you're creating and how you prefer to work. One thing to keep in mind is that most of these paints are compatible with one another, especially within the same brand. You might find that you prefer to work with heavy body acrylics but like to add a bit of fluid paint to the mix to tint or thin the paint without diluting it.

TIP

The term "viscosity" is commonly thrown around when describing paint. It refers to the body of the paint, whether it is a flowing paint or has a dense body. Manufacturers use the terms high viscosity and heavy body to describe a thicker, slow-moving paint. Low viscosity paints appear very thin.

Heavy Body
These paints have a thick, buttery consistency and typically have excellent color intensity and brushstroke retention. These acrylics work very well for impasto techniques and creating texture. They are highly pigmented and have high viscosity.

Soft Body
These paints, as the name suggests, have a slightly thinner consistency than heavy body acrylics. This is known as low viscosity. A good soft body tends to have smooth blending and layering capabilities. These acrylics are an excellent middle ground paint with a range of capabilities.

Fluid
These paints have a consistency similar to oil or even water, and are often used for pouring and other fluid techniques. These acrylics are great for creating smooth, even washes of color or very fine detail.

Supports for acrylic painting

Acrylic paint can stick to a wide range of surfaces. Two of the most common are canvases and wooden boards. The projects in this book are painted on wooden boards that have been primed with gesso. You can easily paint these same projects on canvas instead.

CANVASES

Canvas can come stretched, unstretched, primed, unprimed, or on a panel or board. Most often you will see stretched canvas, already primed with gesso, for sale in many art stores. Sometimes they even come in multipacks and are economically priced. You can also get pads of canvas paper which is great for practicing. It can later be stretched or framed.

WOODEN BOARDS

These often come unprimed (although primed gesso boards are also available) and are usually made from plywood or hardboard. You can even cut your own boards. Sometimes you may need to sand the board before priming with gesso. Boards have a smoother texture than canvas, which is why some artists prefer them.

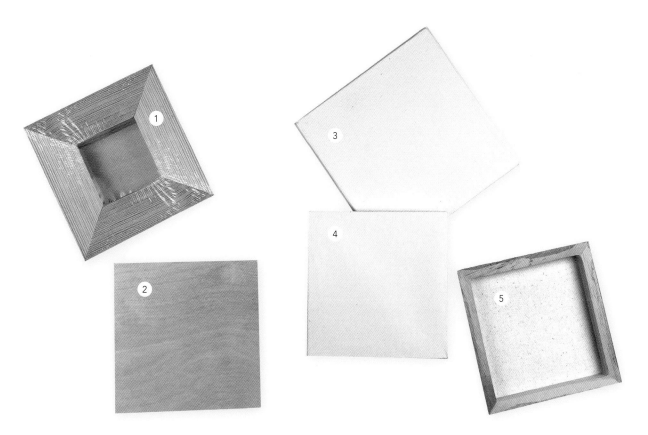

Picture frame with wooden back (1)
Wooden board (2)

Primed canvas on board (3)
Stretched canvas on frame (4)

Back view of stretched canvas on frame (5)

Drawing materials & brushes

BASIC DRAWING MATERIALS

To complete the underdrawings (or any preliminary sketches) for your paintings, you'll want pencils, an eraser, and a ruler at least. You can also use pastel or charcoal pencils to complete the underdrawings if you prefer. Softer pencils such as 2B or 4B work well, but almost any pencil can work.

From left to right: Sketchbook, kneaded eraser, pencil sharpener, white eraser, sheets of drawing paper, graphite pencils, pastel pencil, charcoal pencil, viewfinder, low-tack masking tape, workable fixative spray.

TIP
Drawing is the foundation of painting. Keeping a small sketchbook of various subjects that can be used for painting is very useful.

PAINTBRUSHES & MORE

Paintbrushes come in a wide variety of shapes and styles, in both synthetic and natural fibers. For acrylic painting synthetic brushes work well and are typically less expensive than brushes made from natural hair.

- **Palette knives** can be used for mixing paints, impasto techniques, or cleaning your palette. **(1)**
- **Flat brushes** are useful for applying broad strokes of color to cover large areas, such as blocking in backgrounds, while also giving clean edges. **(2)**
- **Bright brushes** are another example of a flat bristle brush. Due to their shorter bristle length, brights generate more resistance with the surface, making them ideal for applying short, strong strokes of color. **(3)**
- **Angled flats** are great for blending or cutting in around shapes. **(4)**
- **Round brushes** have a more traditional shape, which comes to a point and can produce a range of marks; the smaller ones are great for finer details. **(5)**
- **Utility brushes** are great for applying gesso and washes. **(6)**
- **Old brushes** can be a great option for adding texture with dry brushing or scumbling. **(7)**
- **Filberts** are a really useful "all-rounder" brush. It's helpful to have multiple sizes. **(8)**

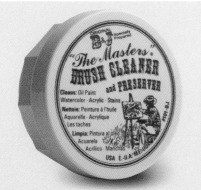

Cleaning your brushes
You'll want to clean your brushes after each painting session (and avoid letting them sit too long in the water as it can cause the brush to break down). Start by removing as much excess acrylic paint as you can in your jar of water and blot the brush on a paper towel. Then, mix a little brush cleaner or soap into the bristles. Rinse thoroughly with clean water and lay flat to dry on a paper towel. Reshape the bristles of the brushes as needed. When the bristles are dry, store your brushes vertically in a container.

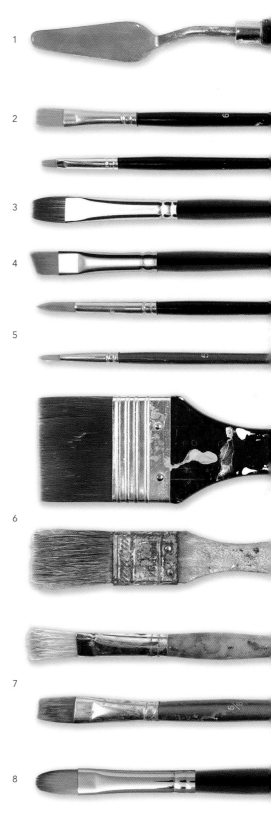

1

2

3

4

5

6

7

8

Painting supplies

GESSO

This is used to prime the surface before painting. Gesso provides a "ground" for your support and acts as a sealant. It also gives the surface "grip." You can find gesso in white, black, clear, or premixed colors. To apply gesso, use a wide flat brush (a utility brush can work) to apply a thin layer onto the surface. Some artists will leave brush marks in the gesso to give it extra texture, while others paint smoothly. To clean your brush, remove any excess gesso from the bristles with a paper towel and then rinse with warm water. Gesso becomes dry to the touch very quickly and you can apply another coat at that point if you wish. The gesso will be cured in about 24 hours.

FIXATIVE

This is a colorless spray used to "fix" drawings in graphite, pastel, or charcoal on your surface before you start painting. This stops them from smudging.

GLAZING MEDIUM

This is not an essential medium (water can work instead); however, it's great if you plan on using the glazing technique (see page 29).

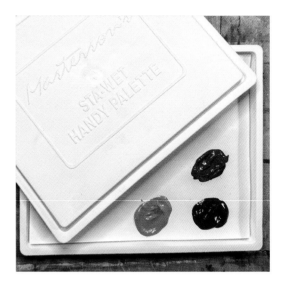

Sta-wet palette with paint.

PALETTES

Palettes are used to mix paints. There are many different styles to choose from, and they can be made out of wood, glass, ceramic, or plastic. You can also use paper plates or disposable palette sheets. Palettes are convenient as there is no cleanup required once you have finished painting; you simply tear out the sheet and toss it away. Because acrylic paints dry very quickly, the sta-wet palette is also a great option. There are many tutorials available online for DIY versions. Essentially a damp sponge is kept under the palette paper so the paint doesn't dry out. It also comes with a lid so you can store the paints like this for several days.

OTHER MATERIALS

You will need some paper towels and/or old rags. These are helpful for spills and wiping brushes. You'll also want a container or two of water for cleaning your brushes. Palette knives come in all different shapes and sizes; they are a great option for mixing paint colors.

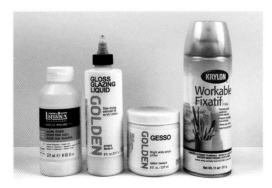

Left to right: Glazing medium, gloss glazing medium, gesso, and fixative spray.

Setting up a workspace

One of the advantages of working on a smaller scale is you don't need much room for your workspace. You can even paint on your dining room table if that's what works best for you. Having a dedicated workspace can help you stay productive and focused on your painting pursuits. No matter what your set-up, below are a few things to consider to get the most out of your workspace.

Lighting: Keep in mind that not all lighting is the same. Differences can include the temperature and hues (warm versus cool), which can affect how we see color. Make sure the still-life set-up and your workspace have the same temperature lighting.

Table: When working on smaller scape paintings, most artists prefer to sit instead of stand, but you should do what is most comfortable for you.

Easel: Tabletop easels work best for smaller paintings.

Chair: You don't need a special type of chair, but you do want to be comfortable. Consider whether you want a backrest on the chair. An adjustable chair can be helpful, so you can move it to fit your workstation or if you adjust the height of your still-life set-up.

Storage: You'll want a storage system for your paints, brushes, canvases, and other materials. It's helpful to have your storage close to your workspace, but if that's not possible, investing in a cart can be a great idea.

Cart: Carts can be helpful for storing your supplies and can be easily relocated to wherever you set up a painting station.

Workstation: A separate workstation can be helpful, if space allows.

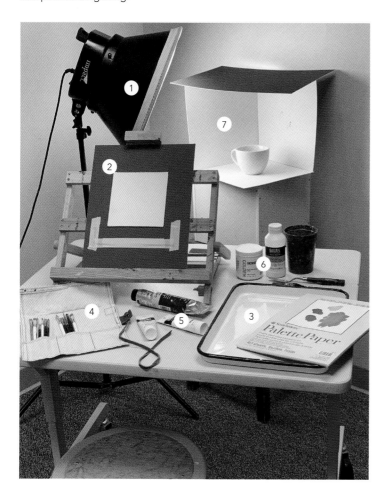

Daylight lamp **(1)**
Desktop easel **(2)**
Palette **(3)**
Brushes **(4)**
Paints **(5)**
Gesso and fixative **(6)**
Shadow box **(7)**

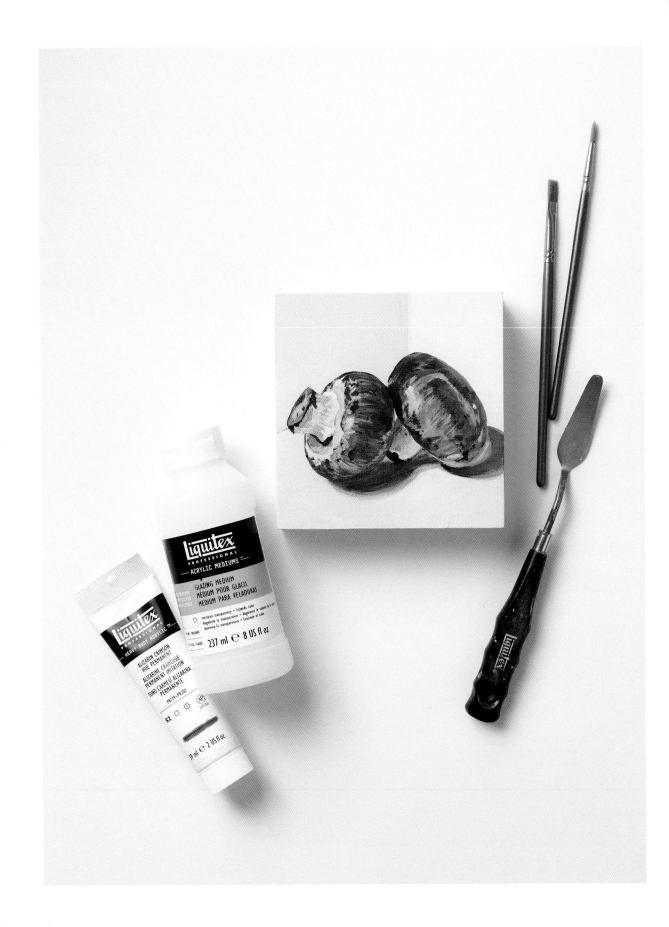

TECHNIQUES

If you need to know more about a technique or want to expand your skills, the detailed explanations in this chapter will help you to feel confident with the building blocks of acrylic painting.

Transferring a drawing

Prior to beginning a painting, many artists will start with an underdrawing directly on their gessoed surface using a graphite or pastel pencil. Some artists transfer drawings from their sketchbooks to save having to redraw the subject matter. There are other methods for transferring and enlarging your drawing, such as the "grid" method. The approach shown here works best for the exercises in this book.

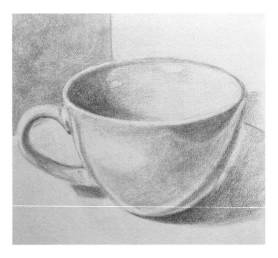

Initial sketch

Ensure tape will hold the tracing paper without twisting.

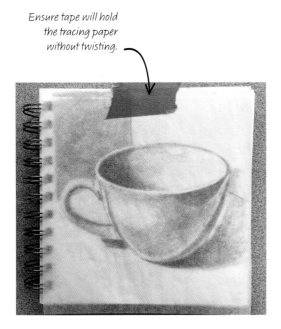

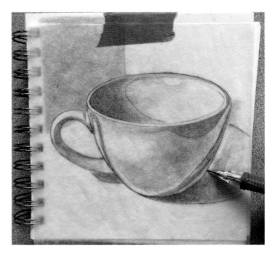

1. Place a piece of tracing paper over the top of the drawing that you wish to transfer. You can always cut the tracing paper to size to avoid wasting an entire sheet. Use a piece of low-tack masking tape or washi tape to hold the tracing paper down.

2. Use a pencil (or thin permanent marker) to trace the outline of the drawing along with important information, such as the outline of the highlights or any prominent shadows. How much detail you include is entirely up to you. It's helpful if your lines are fairly dark.

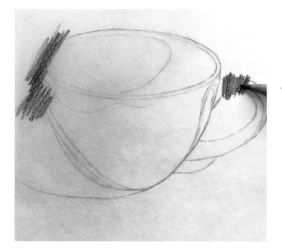

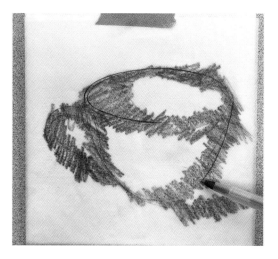

3. Remove the tape and flip over the piece of tracing paper. On the back, use a soft pencil (4B works well) to shade the reverse side of the traced drawing. Make sure to shade over the top of all the lines.

4. Align your tracing paper (shaded side down) on the painting surface and tape it down with masking tape. Use a pen or stylus to trace over the lines, taking your time. The impression left should make a good starting point for your painting. Feel free to darken any lines directly on the surface with a pencil. You can fix your drawing before you start painting.

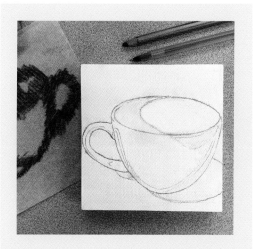

You can also employ this technique to transfer a drawing using charcoal or a pastel pencil, as shown in the photo above.

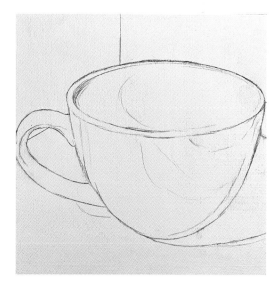

Final image ready for wash

Underdrawing

Underdrawings can be very useful when beginning a painting, especially if you decide to try a more complex still-life composition. Even having very simple lines on your canvas before you begin painting can be extremely helpful for determining value and color placement. Try using a viewfinder to determine a strong composition, even if it's a singular object.

An underdrawing can be approached in a variety of ways, using various materials such as charcoal, pastel, graphite, or slightly diluted acrylic paint.

The red pastel pencil allows you to see the linework against the canvas as you begin painting.

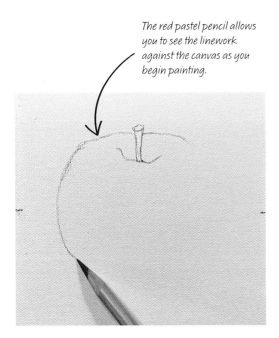

Core shadow

Highlight

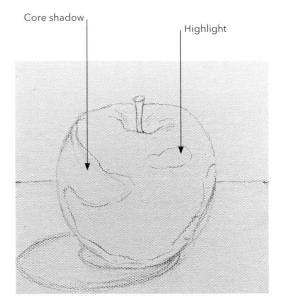

1. It can be helpful to start with a few guidelines, such as the vertical and horizontal axis of the canvas. You can place the marks at the edges instead of drawing a complete grid. These marks will help you position the subject matter.

2. In addition to the basic outline of the object, including important information such as the outlines of the highlights, core shadow, cast shadow, and reflected light can be beneficial.

TIP

If you use a material that can easily smudge, such as pastel, charcoal, or graphite, it's a good idea to "fix" your drawing before you begin painting. You can also apply a layer of transparent gesso on top if you prefer.

Core shadow Highlight

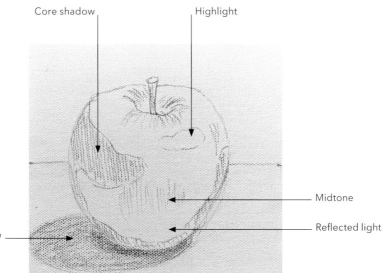

Midtone

Cast shadow

Reflected light

3. This step is optional, but some artists find it helpful to add some shading to the key areas of the composition. This will help you determine the tonal values as you begin painting.

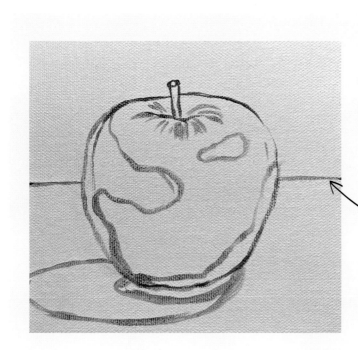

In this underdrawing of an apple, I used a flat brush and diluted (with glazing medium) Burnt Umber paint, to establish the basic outline along with some of the major shifts in value.

Don't worry if your lines aren't perfect, as you can easily adjust the shape as you begin to paint.

Underpainting

An underpainting, like an underdrawing, isn't required, but it can be very helpful as you begin your painting. An underpainting helps you establish the tonal value structure prior to adding color. Typically, underpaintings are completed using neutral colors, such as Burnt Umber or Raw Umber. In the form of underpainting known as "grisaille," the color is gradually diluted to create a range of values. The more the paint is diluted, the "lighter" in value it becomes.

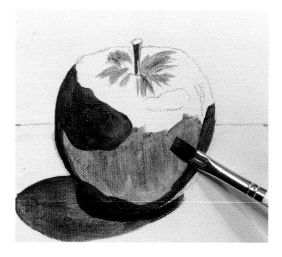

2. Continue to dilute the paint as you work from dark to light values.

1. Many artists choose to start with the darkest values. Start with Burnt Umber and dilute it slightly with a tiny bit of glazing medium or water. Using a flat brush, block in the darkest areas following the guides on the underdrawing.

Diluted Burnt Umber paint

TIP
Remember that an underpainting is intended to be painted over once it has dried, so it doesn't matter how neat it is.

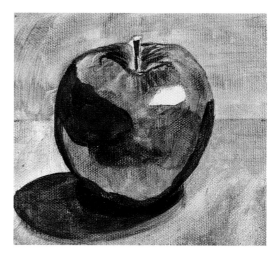

3. Block in the rest of the object as well as the background and foreground. You now have a monochromatic version of the object along with a good understanding of its values. Once the painting is dry, which doesn't take long, you can start painting color over the top.

Wash

A wash is one way of setting a ground for a painting. The ground is the layer used to prepare a support for painting, and its color and tone can affect the chromatic and tonal values of the paint layers applied over it. It can feel less intimidating to paint on top of a color instead of white. Another perk is that it provides a middle value, so it's easier to block in your lights and darks.

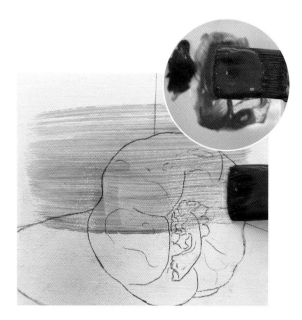

2. Use a 1-in (2.5-cm) flat utility brush to apply the wash on top of your surface. Let it dry completely before beginning your painting.

Ensure the wash is fully mixed before applying.

1. The surface should be gessoed and have your underdrawing fixed on it before beginning the wash. Select your wash color and put a small dot on your palette. Add a small amount of glazing medium (or water) to thin your paint to a transparent consistency. Your wash can be lighter or darker, so long as it's transparent.

Brush in both horizontal and vertical strokes.

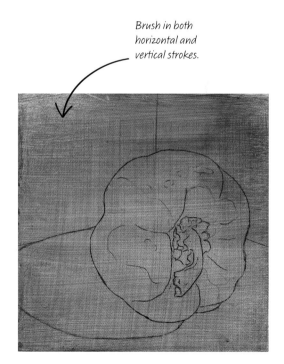

Dried wash on wood panel

Wet on wet versus wet on dry

Wet on wet refers to adding wet paint into existing wet paint, which causes the acrylics to blend. Acrylic paint dries quickly and it's essential that the colors are wet if you want to achieve a blend.

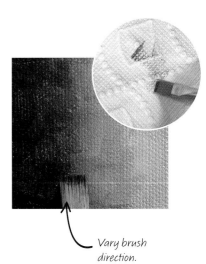

To blend multiple colors together, place them side by side, and while they are still wet, use your brush to work the colors into each other. Occasionally, you may want to wipe the excess paint off your brush. A gentle back-and-forth motion will produce a softer blend. Sometimes it can be helpful to layer the paint for a better blend. Let each layer dry in between adding more paint, so you build it up.

Vary brush direction.

TIP
Using a medium to extend the drying time of the acrylic paint can be helpful when blending, but it's not required.

Brush in both horizontal and vertical strokes.

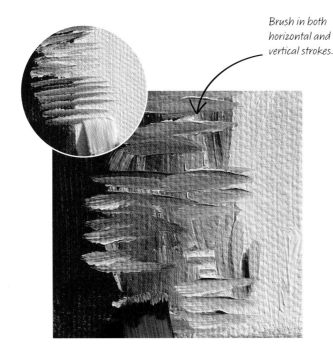

You can also use other strokes to create different looking blends. For more texture, try crosshatching. Traditionally a drawing method, crosshatching involves moving your brush both horizontally and vertically in overlapping strokes. You could also try tapping your paintbrush for a different type of effect.

Finished effect

Wet on dry refers to adding wet paint on top of dry paint to build up layers. Allowing layers of paint to dry is the best way to build up the opacity of the color. Most acrylic is fairly opaque, but you will notice that some colors are more opaque than others. An Indian Yellow is on the transparent side whereas Titanium White is the most opaque paint. As you layer the acrylic paint you will build up the opacity. Wet on dry is also how you can achieve a crisp edge, or you can try out some of the other techniques mentioned in this book, such as glazing or scumbling.

Note: Most colors have the opacity/transparency level on the label.

1 layer 2 layers 3 layers

Cadmium Yellow is a semi-opaque color. In order to build up the opacity, multiple layers are applied with ample drying time in between.

A single layer of Cobalt Blue and Titanium White was applied to the canvas.

Scumbling and dry brush effects work well on top of a dried layer of paint.

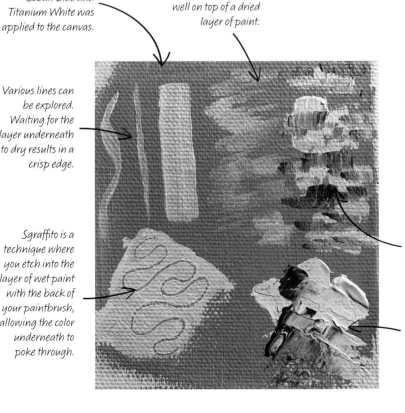

Various lines can be explored. Waiting for the layer underneath to dry results in a crisp edge.

Sgraffito is a technique where you etch into the layer of wet paint with the back of your paintbrush, allowing the color underneath to poke through.

Wait for the paint to dry and then add some crisp linework or details with various brushes. You can work wet on wet on top of layers of dry paint to create blends or try some dry brushing or scumbling for texture.

Wet-on-wet techniques can be applied on top of a dried layer of paint.

Impasto techniques can be applied on top of dried paint.

Impasto

Impasto is all about texture that you can see and feel. Texture can be increased with mediums such as modeling paste or gel, but on its own, acrylic paint can be utilized with impasto techniques. Impasto can be viewed as sculpting with paint. You can apply thick paint using anything, including a brush, a palette knife, or your fingers, or even by squeezing paint directly from the tube onto the canvas. Heavier bodied acrylic paints tend to work better for impasto techniques. This technique can be challenging on smaller surfaces, but the mushroom below illustrates some simple impasto techniques. First noticeable in the paintings of Venetian Renaissance artists Titian and Tintoretto, many other artists throughout history and today utilize this technique. Some of these include Vincent Van Gogh, Frank Auerbach, and Leon Kossoff.

Shorter bristle brushes work best for impasto.

Palette knives create texture when used in different directions.

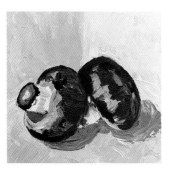
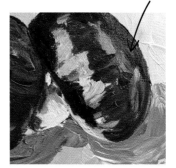

Dry Brush / Scumbling

Scumbling is an acrylic painting technique that involves brushing thin or broken layers of paint over another so that some of the paint beneath is visible. The effect is a broken, speckled, or scratchy color that offers a sense of depth and beautiful color variation. The paintbrush is often moved in a circular motion. Another variation of this is referred to as dry brush. The dry brush technique is a useful method for suggesting texture in a simple and effective way and can be used to add visual interest to areas of solid color. Only a small amount of undiluted paint is used on the brush and quick, light strokes should be made, allowing the dry surface below to remain visible through the scratch-like brush marks.

The dry brush technique adds texture to the teapot's surface.

TIP
Try doing a test brushstroke on a separate surface (a piece of paper will do), just to be sure that you have the desired texture before you work directly on your painting.

Glazing

Glazing is a technique that involves thinning down the paint into a transparent consistency and applying it on top of an existing layer of dry paint. To thin acrylic paint, it's best to use glazing medium (you can try matte or gloss medium too), but water can also work. The effects of glazing can be subtle or used in layers to create a more vibrant appearance.

Note: When thinning acrylic paint with water, be sure to check how much water can be added before breaking down the binder of the paint. Many paint manufacturers recommend no more than 20-30 percent. Binders help with adhesion, help the paint dry fast and evenly, and provide the characteristic glossy appearance of acrylic paint. The binder is also known as the acrylic polymer. Its primary functions are to hold the pigment and to form a flexible, protective film once the paint has dried.

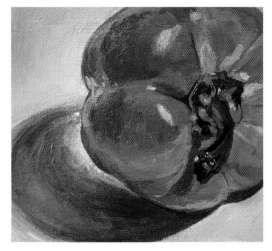

Some orange has been glazed into the cast shadow in this painting.

1. To thin the paint, add a small amount of glazing medium (or some water). The more medium is added, the more transparent the paint will be. You can experiment with creating a range.

2. You can glaze with a single color and experiment with adding layers of transparent paint. This would be similar to creating different values, as in grisaille painting.

3. Experiment with different colors and overlay them on top of each other. Let each layer dry before adding a new layer. This will allow you to see how colors interact with one another.

TIP

Some paint colors are more transparent than others (this information is usually found on the tube of paint). Transparent colors tend to work better for glazing, but any color can work.

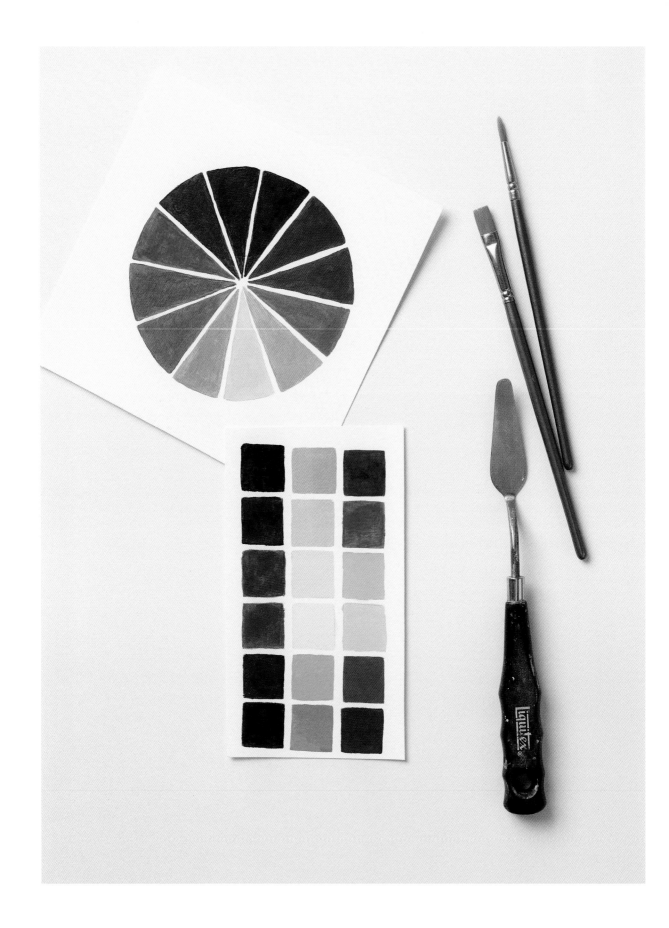

COLOR

Color theory is both the science and art of using color. It's an exciting and complex
subject that can be explored at your leisure. This chapter explains why certain
colors work well together, how to mix paints, and how to arrange a palette.

Color theory

Color theory explains how humans perceive color and the visual effects of how colors mix, match, or contrast with each other. Color theory also involves the messages colors communicate and the methods used to replicate color. There are many great books about the subject if it's something that you want to explore further. When light waves hit objects, the colors that we see are the result of certain waves being reflected back to us. When we look at a painting, these waves of light throw back colors that are determined by the pigments within the paints.

COMPONENTS OF COLOR

Hue means color. When it is used in a color name, it indicates that a modern pigment has been used instead of the traditional one. For example, Cadmium Red Pale Hue is a "color of cadmium red pale." It is important to note that a hue color is not necessarily inferior.

Value defines how light or dark a given color can be.

Saturation refers to the intensity and vibrancy of a color. As the saturation increases, the colors appear purer. As the saturation decreases, the colors appear more washed-out or pale.

PRIMARY, SECONDARY, AND TERTIARY COLORS

Color wheels and charts are a great way to learn about color. They are used to illustrate the relationships between colors. Colors are grouped into three categories: primary colors, secondary colors, and tertiary colors. Primary colors (red, blue, and yellow) are the only colors that cannot be mixed from other colors. Primary colors are the source from which all other colors are created.

By mixing primary colors together we can create the secondary colors: orange, green, and violet. By mixing a primary color with a secondary color, you can create tertiary colors: red-orange, yellow-orange; yellow-green, blue-green; blue-violet and red-violet.

As you are painting, you will come across different versions of each primary color. The different attributes, such as saturation and temperature, mean that you can choose a paint color to refine your palate and suit your subject. For example, in the red family there is Cadmium Red, Vermillion, Alizarin Crimson, and many others. For blues, you could choose from Ultramarine, Phthalo, Cobalt, and so on.

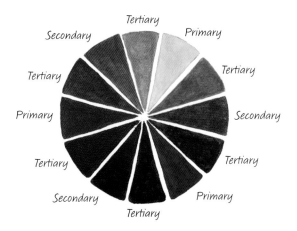

This color wheel shows painted representations of the primary, secondary, and tertiary colors.

Cadmium Red

Vermillion

Alizarin Crimson

ANALOGOUS COLORS

Analogous colors are colors next to each other on the color wheel. They are often used in groups of three or four. Whether it's red, red-orange, and orange, or violet, red-violet, and red, grouping these like-minded tones will create an interesting, harmonious, and monochromatic look within your paintings.

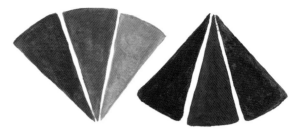

Red, red-orange and orange is an example of an analogous color scheme, as is blue-violet, blue and blue-green.

COMPLEMENTARY COLORS

Complementary colors are colors that are across from each on the color wheel. Knowing which colors are complementary to one another can help you make choices when it comes to mixing paint. For instance, complementary colors can make each other appear brighter, they can be mixed to create effective neutral hues, or they can be blended together for shadows. Red and green are complementary colors, as are orange-red and blue-green.

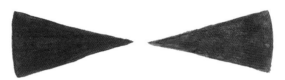

Complementary colors red and green

COLOR TEMPERATURE

Color temperature often refers to warm colors and cool colors. When the color wheel is divided, there are warm colors on one side and cool colors on the other. However, when you dive deeper into color you will learn that although red is commonly thought of as a warm color, there are both warm and cool variations of red. For example, Cadmium Red is a warm red whereas Alizarin Crimson is cool.

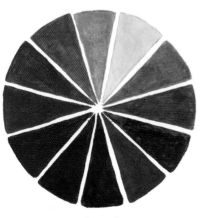

Warm colors

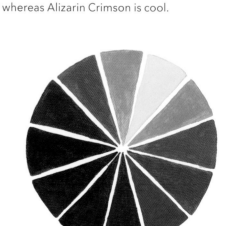

Cool colors

Tonal range & value

Value is an important component in a painting. It's what helps create space and the illusion of depth. Without a range of values, paintings tend to look flat. A tone is a color mixed with gray. You can create a range of tones within your painting.

ASSESSING VALUE

Creating a value scale, or looking at your image in black and white, can help you easily figure out the values of all your colors and make sure that you have strong contrasts from highlights to shadows.

MAKING A VALUE SCALE

To create a value scale (or grayscale), you'll want some gessoed canvas paper or cold press watercolor paper. Draw out ten boxes of equal size (1 x 1in/2.5 x 2.5cm works well) on your paper and label them 1–10. Start by painting the first box with Titanium White and the last box with Ivory Black. Now go back to box 2 and start with Titanium White, adding a tiny dot of Ivory Black and mixing thoroughly. Continue to add a bit more Ivory Black for each box as you progress toward box 10. You should end up with a scale showing an even gradation from white to black, or light to dark. You can always make adjustments to the values when the paint has dried.

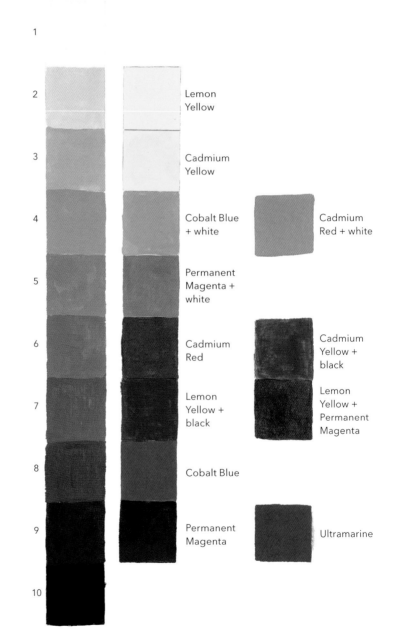

1

2 Lemon Yellow

3 Cadmium Yellow

4 Cobalt Blue + white Cadmium Red + white

5 Permanent Magenta + white

6 Cadmium Red Cadmium Yellow + black

 Lemon Yellow + black Lemon Yellow + Permanent Magenta

7

8 Cobalt Blue

9 Permanent Magenta Ultramarine

10

USING A VALUE SCALE

To help assess the range of values you need for painting a subject, start by holding your grayscale next to your set-up or reference. Squint to blur out the details, allowing you to focus on the important shapes and shifts in value. Notice the lightest and darkest areas of the object. As you observe, look for the values that fall in between. This is usually a range of middle values, referred to as midtones. Where do these values fall on the scale you created? Look for contrast. Is there enough of a value difference between your object and the backdrop? You can always make adjustments as needed.

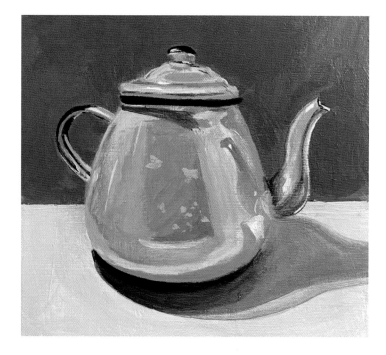

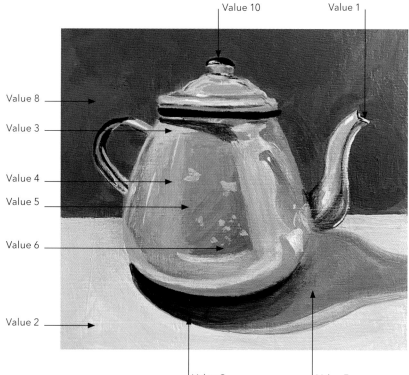

Color mixing

Keep in mind that color mixing will take practice. The more you practice, the more your confidence will grow. There may be times when you are able to use a color straight from the tube, but oftentimes you will be mixing paint to adjust these colors. Adjustments could include lightening, darkening, lowering the saturation of a color, and so on.

TINTS AND SHADES

A tint is white mixed with a color to lighten it. It's important to note that while white does lighten a color, it doesn't brighten it. Mixing black into a color creates a shade. Make your own tints and shades chart with your selected color palette.

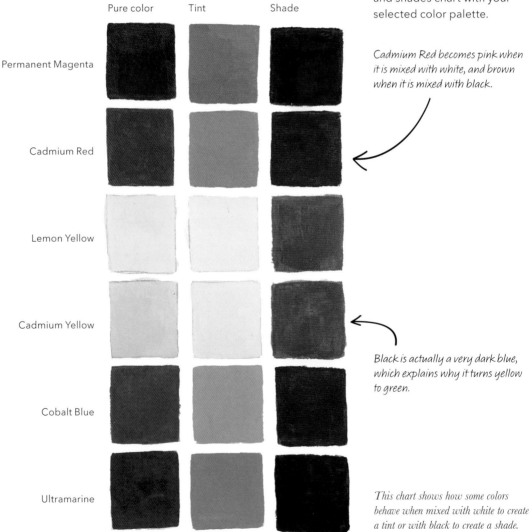

Pure color Tint Shade

Permanent Magenta

Cadmium Red

Lemon Yellow

Cadmium Yellow

Cobalt Blue

Ultramarine

Cadmium Red becomes pink when it is mixed with white, and brown when it is mixed with black.

Black is actually a very dark blue, which explains why it turns yellow to green.

This chart shows how some colors behave when mixed with white to create a tint or with black to create a shade.

Color mixing chart with rows and columns labeled: Titanium White, Ivory Black, Burnt Sienna, Burnt Umber, Cadmium Red, Alizarin Crimson, Cadmium Yellow, Lemon Yellow, Yellow Ochre, Ultramarine, Cobalt Blue, Emerald Green, Viridian.

Creating a chart using all your paint colors will teach you a lot about how different colors interact when they are mixed together. Then, as you match colors of objects when painting, you'll have a better understanding of how to mix the color you are looking for.

TIP

Different brands of acrylic paints can have different names to describe the same colors, which can be confusing. To ensure you have the right color, check the Standard Pigment Number on the side of the tube.

Arranging a palette

Every artist has their own way of arranging their palette. Due to the quick drying nature of acrylic, some artists opt for sta-wet palettes or add a medium to extend the drying time of the paint.

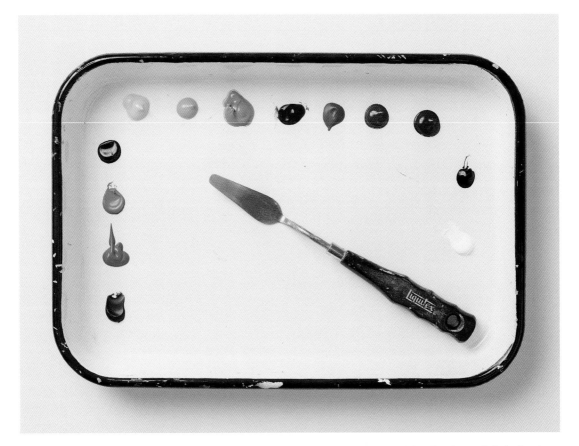

My palette layout, clockwise from lower left: Ultramarine Blue, Cobalt Blue, Emerald Green, Viridian Hue Permanent, Lemon Yellow, Cadmium Yellow, Yellow Ochre, Alizarin Crimson, Cadmium Red, Burnt Sienna, Burnt Umber, Ivory Black, Titanium White.

TIP
Arranging your colors around the perimeter of the palette allows for plenty of space for mixing in the center. To preserve your colors while taking a break from painting, try covering the palette with plastic wrap or a large plastic ziplock bag.

HOW TO MIX ON A PALETTE WITH A KNIFE

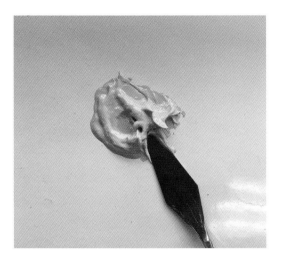

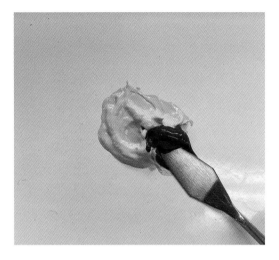

1. Using a palette knife, take some of the first color (in this case Cadmium Yellow) and place it on your palette. Spread the paint out a bit with the palette knife.

2. After wiping your palette knife, take a little of the second color (in this case Viridian Hue Permanent) and begin mixing it into the first color using your palette knife.

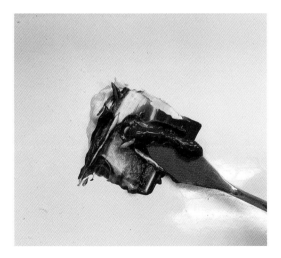

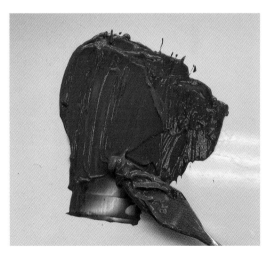

3. Next, begin scraping up all the paint and squashing it down flat onto the palette. You'll see the colors starting to mix.

4. Repeat this process until the color is smoothly blended without any streaks. You can also use a paintbrush for this instead of a palette knife.

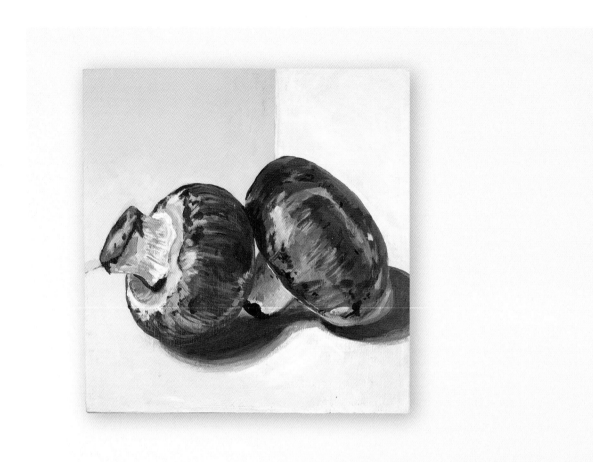

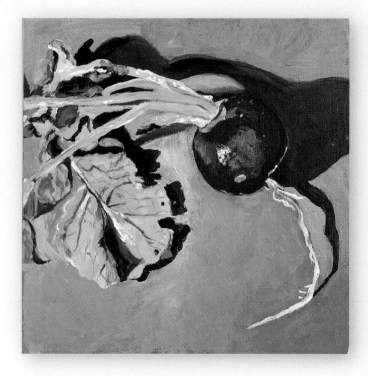

PROJECTS

Use the knowledge you have acquired from earlier chapters to paint the ten small projects featured in this chapter.

WHITE MUG

White on white is a fun challenge for artists of all ability levels. This extremely limited color palette allows you to focus on mixing values and the application of the acrylic paint. Keep in mind that wet-on-wet paint will allow you to blend and smooth, while letting layers dry allows you to build up the paint. Always pay attention to how much paint is on your brush as well as the pressure with which you are applying the paint. Soft, light pressure will produce a delicate application of paint, whereas applying heavier pressure will produce a bolder look.

PAINT COLORS

☐ Titanium White
■ Ivory Black
■ Ultramarine Blue

TOOLS AND MATERIALS

☐ Wood panel (5 x 5in/13 x 13cm) primed with white gesso (see page 16)
☐ Graphite or colored pencil
☐ Eraser
☐ Ruler
☐ White gesso
☐ Fixative spray
☐ Small palette knife
☐ Palette
☐ Container of water
☐ Paper towels
☐ Glazing medium (optional, can use water)
☐ 1-in (2.5-cm) flat brush (for wash)
☐ Bright brush (size 6)
☐ Angled brush (size 5)
☐ Flat brush (size 8)
☐ Round brush (sizes 1 and 6)

SET-UP

Place the mug on a white matboard and position a directional light source coming from the upper left. Move the light around to experiment with shadows on the mug. Take photographs until you find the composition with the shadows and highlights that interest you the most. I decided I wanted to fill the panel with as much of the mug as possible.

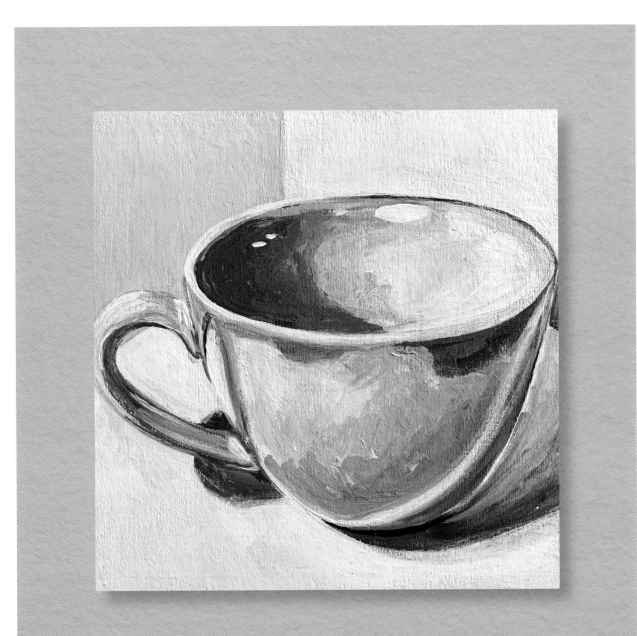

Save your purest
whites for last. Adding
highlights makes
your object pop.

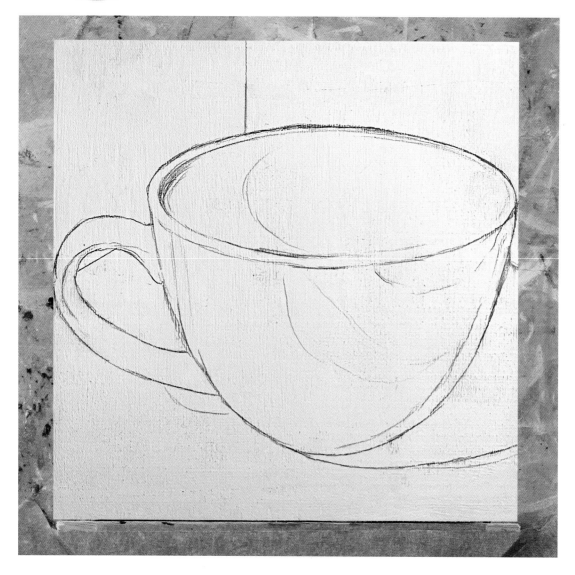

1. UNDERDRAWING

Using a graphite or colored pencil, draw the outline of your mug and its cast shadows. Look at the other lines and shapes you notice and include the most prominent ones in your drawing. It's helpful to use a fixative spray on your panel when you are finished, before applying a wash.

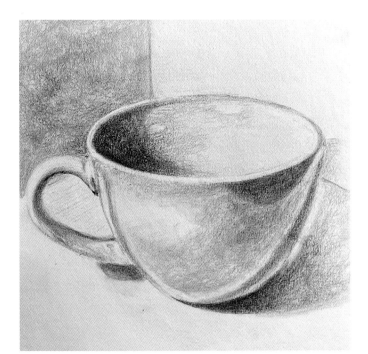

TIP
Create a sketch to explore the form before you begin painting. This will allow you to observe the value structure.

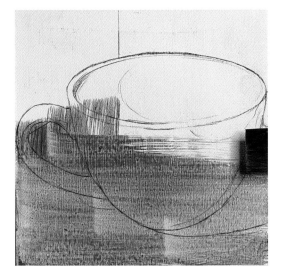

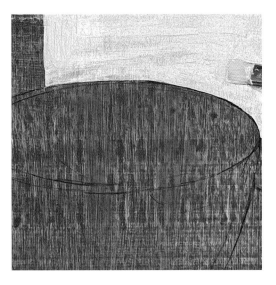

2. WASH

A wash sets a middle value and ground for your painting. This Ultramarine Blue wash, applied with a 1-in (2.5-cm) flat paintbrush, gives the painting an overall cool feeling, but the color of your wash can easily be changed—Alizarin Crimson or Burnt Umber produce a warmer tone.

3. BACKGROUND

Use a size 6 bright brush to apply a medium light gray to the background. This color can be made by mixing Titanium White with a bit of Ivory Black and a dot of Ultramarine Blue. Applying one layer may allow a bit of the wash to poke through, so if you prefer more opaque coverage, let that layer dry and then apply a second coat.

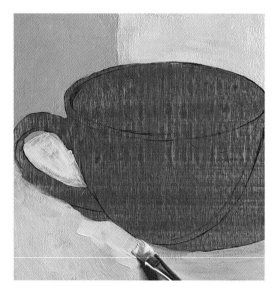

4. FOREGROUND

After the background is blocked in, mix a light gray that matches the reference and apply it to the foreground with a size 5 angled brush. The angled brush makes it easier to cut in along the edges of the mug and the cast shadow.

5. CAST SHADOW

For the darkest area of the cast shadow, mix a medium dark gray and use a size 5 angled brush to fill in the area. If you need to reshape the cast shadow, use the foreground color to rework the area.

TIP

Don't have these exact paintbrushes? No problem! You can substitute many of these brushes for similar ones.

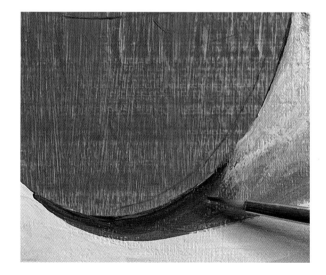

6. BLENDING CAST SHADOWS

Use a size 6 round brush to blend in several values of gray and create a gradient effect on the cast shadow. Work quickly while the paint is wet so the edges can soften into one another.

7. HANDLE SHADOW

Using the same techniques, add a cast shadow beneath the handle of the mug. Applying the paint with a gentle pressure will allow it to maintain a soft edge as it transitions out from the mug.

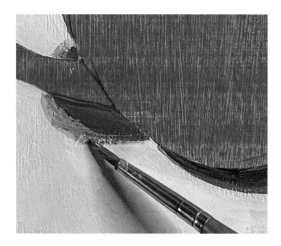

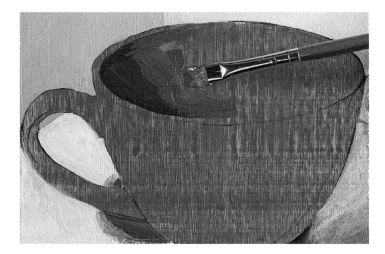

8. DARK VALUES

Starting with the inside of the mug, begin to block in the darkest values with a size 6 bright brush.

9. BLENDING GRAYS

You can create a range of grays by mixing more Ivory Black into your Titanium White. Quickly blend in a range of grays before the paint dries, working from dark to light.

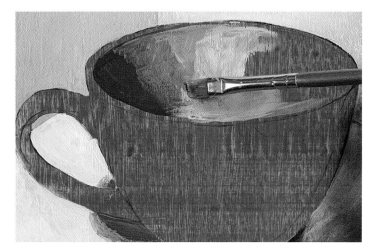

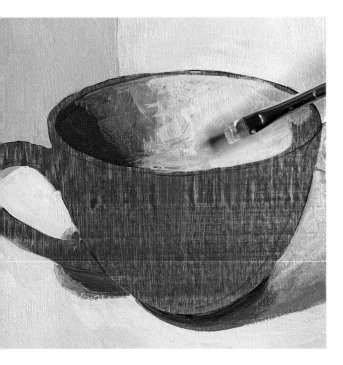

10. LAYER TO BLEND

Continue to work your brush back and forth between the values of gray to soften the transition. You can always make adjustments to your values as needed.

TIP
I will often wipe my brush on paper towel while I'm blending to remove excess paint and create a cleaner, smoother blend.

11. FRONT OF THE MUG

After the inside of the mug is complete, start to block in the front. I often work dark to light when it comes to values, but also work back and forth between the different values.

12. MIDDLE VALUES

When you observe the mug, you'll notice that a large section of it is a middle value. If you squint at the reference image, it will blur out the details and allow you to see the main value. Using a size 6 bright brush, fill in the center of the mug with a light gray.

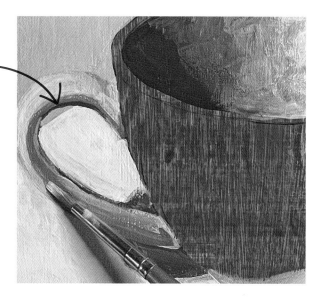

Finer details require a small brush.

13. PAINT THE HANDLE

Looking at the handle, you'll notice there are dark, medium, and light values, just like in the rest of the mug. Use a size 1 round brush to fill in the values within the smaller area.

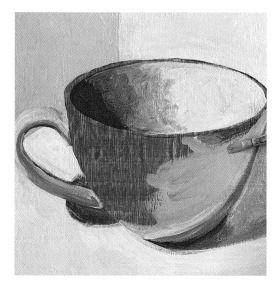

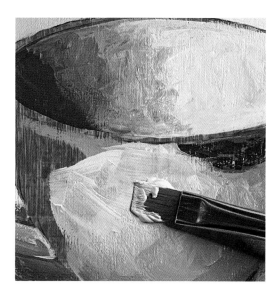

14. BUILD LAYERS

Continue to block in the mug, observing the different values that you see in the reference. As the paint dries, it's easier to assess the value and make adjustments as needed. Acrylic paint can be very forgiving due to its opacity and quick drying time.

15. OPACITY

Using a size 8 flat brush, continue to block in the middle value gray within the mug. Let the paint dry and then build up the layers to increase opacity.

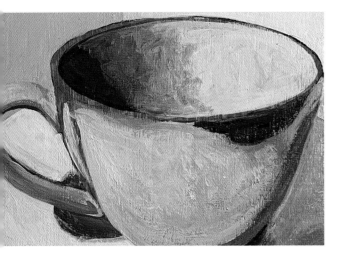

16. CREATING TEXTURE

As you are painting, you can decide if you like a more expressive brushstroke or a smoother, more blended brushstroke. With acrylic, if you try something and change your mind, you can let it dry and paint a new layer on top.

TIP

Texture can be smooth or rough, bumpy, and expressive. The way you move your paintbrush will influence how your blends look. For example, if you scumble the paint, it will look softer compared to blending with crosshatching strokes.

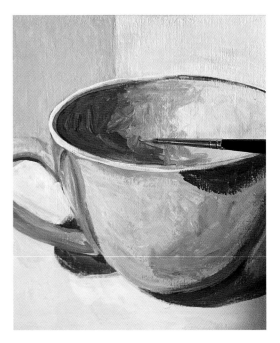

17. ADJUSTMENTS

The more you observe an object, the more you may notice adjustments you want to make. If an area needs to be darker, push it darker; if you notice an area should be lighter, you can also make that adjustment.

18. REFLECTED LIGHT

If you look on the right side of the mug, you'll see some reflected light. Apply a bit of Titanium White with a small round brush to create this reflection.

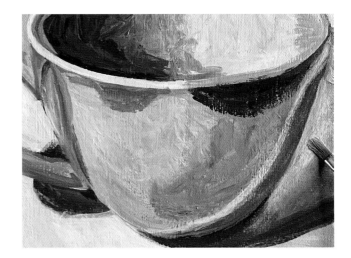

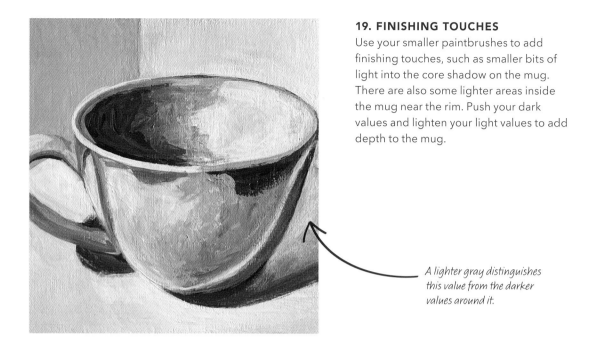

19. FINISHING TOUCHES

Use your smaller paintbrushes to add finishing touches, such as smaller bits of light into the core shadow on the mug. There are also some lighter areas inside the mug near the rim. Push your dark values and lighten your light values to add depth to the mug.

A lighter gray distinguishes this value from the darker values around it.

Highlights can really complete a painting.

20. HIGHLIGHTS

Save the brightest whites for a few highlights on the mug. These highlights really make the mug pop!

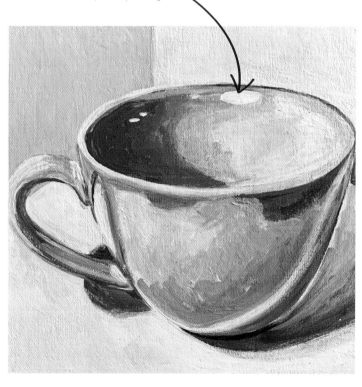

CHERRIES

Cherries are a great subject for painting. They are small and you can easily arrange several within a single composition, allowing you to explore spacing and color variations within the cherries. Although the background is a simple color, the overlay of cast shadows makes the composition more dynamic.

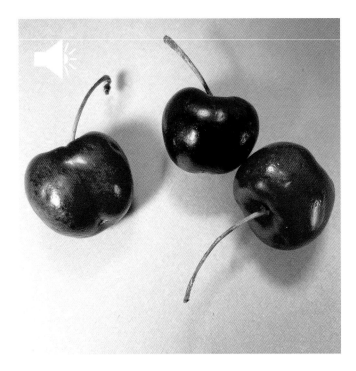

SET-UP
Place several cherries against a backdrop and set up a directional light source.

PAINT COLORS

- ☐ Titanium White
- ☐ Ivory Black
- ☐ Alizarin Crimson
- ☐ Cadmium Red Medium
- ☐ Viridian Hue Permanent
- ☐ Lemon Yellow
- ☐ Yellow Ochre
- ☐ Burnt Sienna

TOOLS AND MATERIALS

- ☐ Wood panel (5 x 5in/13 x 13cm) primed with white gesso (see page 16)
- ☐ Graphite or colored pencil
- ☐ Eraser
- ☐ Ruler
- ☐ White gesso
- ☐ Fixative spray
- ☐ Small palette knife
- ☐ Palette
- ☐ Container of water
- ☐ Paper towels
- ☐ Glazing medium (optional, can use water)
- ☐ 1-in (2.5-cm) flat brush (for wash)
- ☐ Flat brush (sizes 2 and 8)
- ☐ Round brush (sizes 0, 1, and 6)

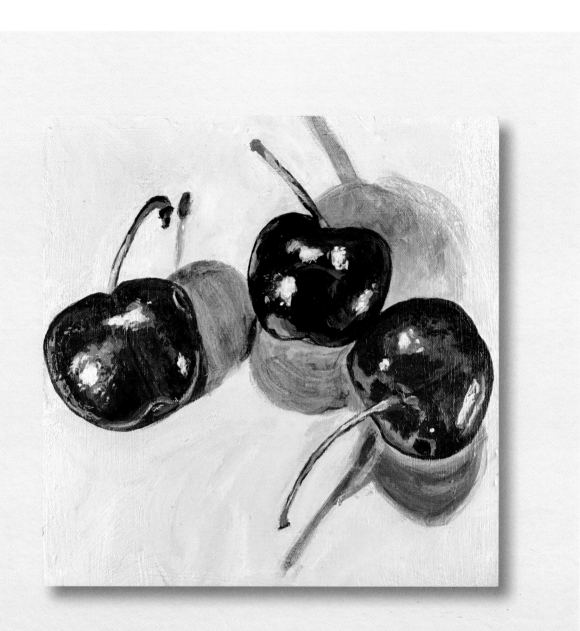

Adding a glazing medium to the cast shadows gives a softer, transparent look. Forgo the glazing for more opaque shadows.

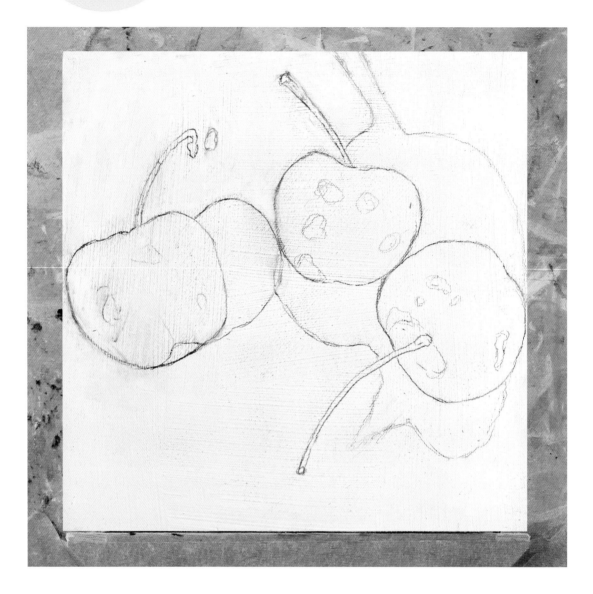

1. UNDERDRAWING

Using either a graphite or colored pencil, draw the outline of the cherries and their cast shadows. Look at the other lines and shapes you notice and include the most prominent ones in your drawing. When you are finished, fix your drawing.

2. APPLY A WASH

A Viridian Hue Permanent wash was used for this painting because green complements red. Apply the wash with a 1-in (2.5-cm) flat paintbrush. Allow the wash to dry before you begin painting. It will dry pretty quickly!

TIP

It's perfectly fine if you get a bit of the background color inside the cherries: you'll eventually paint over it. The beauty of acrylic paint is that it dries opaque and will easily cover up any areas that go outside the lines.

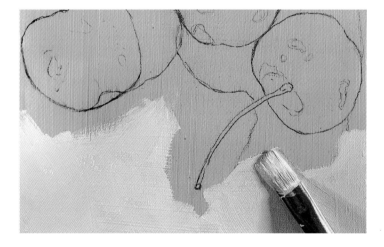

3. PAINT BACKGROUND

Mix Titanium White with a dot of Yellow Ochre and a dot of Burnt Sienna to create the main background color. You can add more Burnt Sienna to the mix for the areas of the background where it's a darker value. Use a size 8 flat brush to apply the paint but feel free to size down as you cut in around the cherries.

4. LAYER THE PAINT

After you cover the background with a layer of paint, assess if there are any areas of the wash poking through and decide if you want to add another layer of paint. In this painting there are two layers of paint covering the background. The brushstrokes are short and overlap in varying directions, creating a soft yet expressive application of paint.

TIP

Some artists deliberately let the wash poke through areas of their painting. This is simply an aesthetic (style) choice.

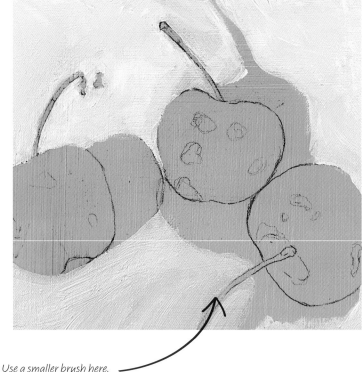

Use a smaller brush here.

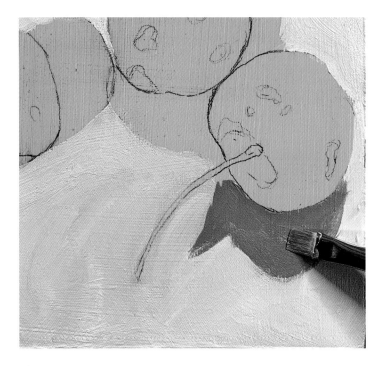

5. CAST SHADOWS

There are many variations of color in the cast shadows. To begin, mix a base color that you can then use as a basis for other variations. To mix this color, begin with the color you used to paint the background (Titanium White with a dot of Yellow Ochre and Burnt Sienna). Add a small dot of Cadmium Red Medium to pull in the local color of the cherries and also some more Burnt Sienna to darken the shadow color.

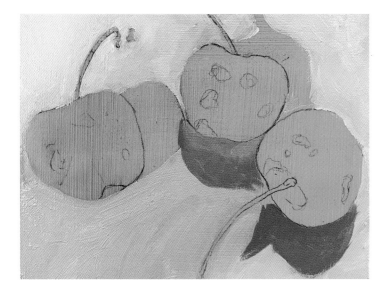

TIP

If you decide that the color isn't quite right, let the layer dry on your painting and then adjust the color and cover it up. Remember that painting is a process and sometimes you'll need to make adjustments. Another method is to create swatches or samples of the colors you mix and hold these up against the object, whether they are from life or a photo.

6. VARIATIONS IN THE CAST SHADOWS

Use your brush to work in several variations of the color (add Titanium White to lighten and Ivory Black to darken). You'll want to work quickly, utilizing the wet-on-wet technique to achieve a blend. Your blend can be smooth or include interesting textures.

7. BLENDING IN LIGHT AND DARK

When observing the cast shadows, you'll notice variations in light and dark values. Using a size 6 round brush, add some lighter values to the cast shadows (glazing medium can be added to make the paint more transparent). For the darker values, add more Ivory Black to your base shadow mix and then use a size 1 round brush to paint the small strokes of dark shadow.

Note: Notice the small cast shadow created by the stem of the cherry on the left. Use your smallest round brush to delicately apply a thin line with a small, oval-shaped dot at the end for the tip of the stem.

TIP

Adding white or black paint to your main color will help you create subtle variations in the shadows.

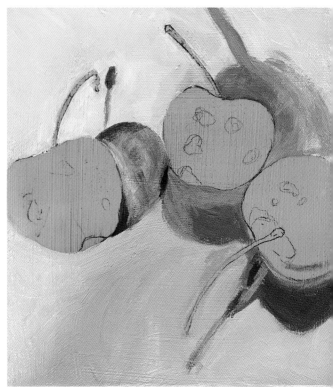

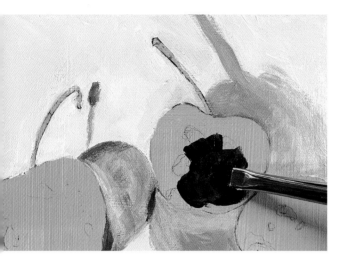

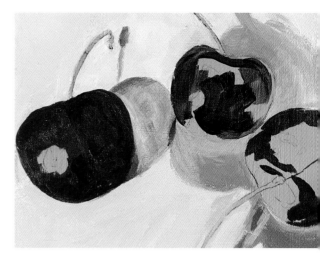

8. DARK VALUES

Starting with the cherry in the middle, block in the darkest values. Begin with a base of Alizarin Crimson and add a dot of Viridian Hue Permanent to darken it. Slowly add more as needed. You may also choose to add a dot of Ivory Black for the darkest areas. Use a size 2 flat brush to block the color in.

Note: Red and green are complementary colors, so to darken the crimson, a dot of Viridian will do the trick. Some artists darken colors solely using complements. Others choose to incorporate black.

9. BLOCK IN DARK VALUES

Moving around to the other cherries, block in the darker values. Start with Cadmium Red and darken with a dot of Viridian. Mix thoroughly using a palette knife. Look for the shapes that the dark values create on the cherries. The shapes you paint don't need to be exact but rather an approximation.

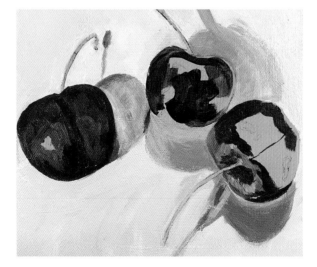

10. MIDTONES

As you continue to block in, you can start adding midtones. Adding more Viridian to your Cadmium Red will darken it. Remember, just a little dot will go a long way. As you continue to darken, use just a small amount at a time. To lighten your values, add white to the Cadmium Red.

Note: Midtones are a range of values. Look for the subtle variations between the different values. It can be helpful to squint to see the shifts in values more easily.

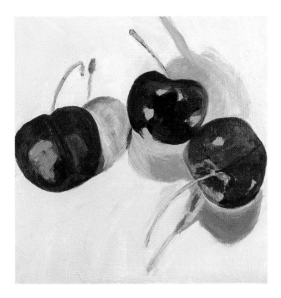

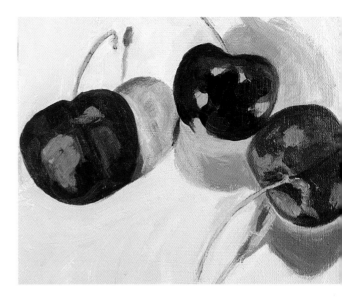

11. LAYERING

As you build layers you can also adjust as needed. It can be helpful to go back and forth between the different midtone values. Pay attention to the direction of the brushstroke. Notice the cherry on the right: near the top, a size 0 round brush was used to delicately paint the highlighted area, utilizing directional lines to help push the roundness of the cherry.

Note: Use a size 0 round brush to apply the thin lines in the center of the two cherries on the outside of the composition. Use Alizarin Crimson with a bit of Viridian or Ivory Black to get the darker color.

12. LIGHTER VALUES

For some of the lighter values on the cherries, white was added to the base color (Cadmium Red for the two cherries on the outside and Alizarin Crimson for the cherry on the inside). Use a size 1 round brush to apply the lighter values near the areas where you see highlights. Later on, pure white will be added on top of the lighter values you are painting now.

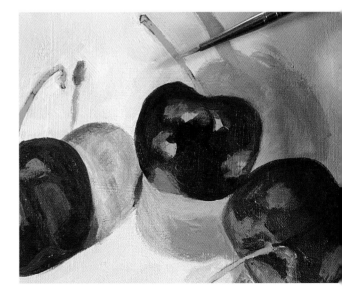

13. STEMS

As you observe the stems, you'll notice shades of green, yellow, and brown. There are areas where the stems are darker and areas of highlights. To create the local color of the stem, mix a bit of Lemon Yellow into the Viridian. Then add a bit of white to lighten it. Use a size 0 round brush to block in the areas where you see this color on all of the stems.

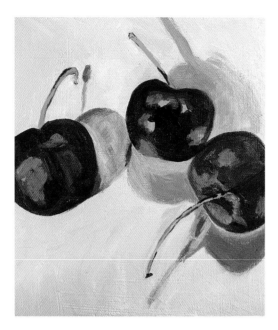

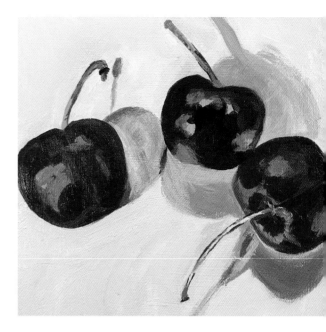

14. DARK VALUES

Mix a dot of Cadmium Red into the Viridian for the darker areas of the stems where you notice green. Use a size 0 round brush to add small strokes of the darker color on all three stems. If you miss any areas, you can always come back and use this color again. When something has several different colors and appears layered, it can take some time to build it up with your brushstrokes.

15. DETAILS ON THE STEMS

Add a few small strokes of Yellow Ochre to each of the stems. There is also a bit of Burnt Umber at the tip of the stem on the left and on the stem in the middle. Apply this using a size 0 round brush. To finish the stems, add a highlight on the right-hand stem using white and a bit of the initial stem color (step 13).

16. HIGHLIGHTS

Use your size 0 round brush to add highlights to the cherries with pure Titanium White. Build these highlights on top of the lighter red values you have already applied. The edges of the highlights form shapes; looking at these shapes can help you recreate what you see with your brush.

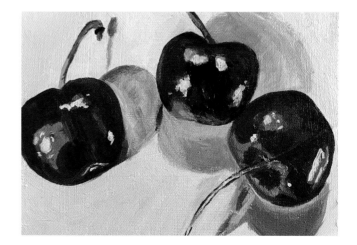

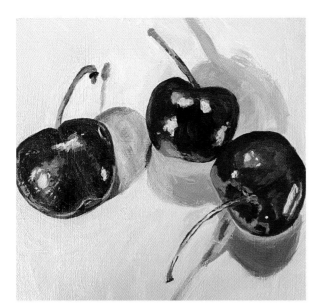

17. ADJUSTMENTS

As you are painting you may notice things you want to change; that's perfectly fine! It's all part of the process and you can make adjustments as needed. This might include making an area darker or lighter, or changing a color completely.

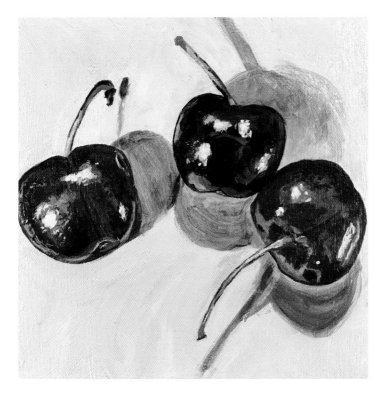

18. FINISHING TOUCHES

Using my smallest brushes, I look for areas where I can add more details to really make the painting come together, such as making a highlight pop with an extra coat of pure white. Remember, you don't need to include every single detail, but including a few can really enhance your painting. Step back and assess your painting from a distance. Better yet, take a break and look at it again after a few hours. This will help you notice anything else you may want to add before calling it finished.

TIP
Push your darker values even darker. Dark values recede and lighter values come forward. Having a range of values in a painting can create a sense of depth and space.

MUSHROOMS

Mushrooms are a fantastic subject to observe when painting. There are so many different varieties to choose from! When you look closely at a mushroom, you'll notice color variations and lots of subtle texture. Placing two mushrooms side by side in opposite directions allows you to explore the texture from different angles.

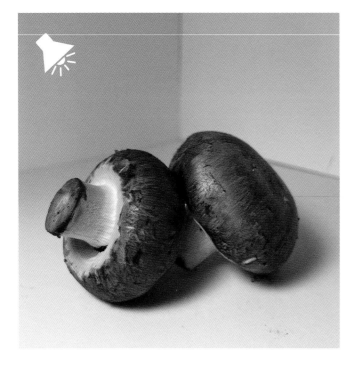

PAINT COLORS

- ▨ Yellow Ochre
- ■ Ivory Black
- ■ Burnt Umber
- ■ Burnt Sienna
- ■ Cobalt Blue
- ☐ Titanium White

TOOLS AND MATERIALS

- ☐ Wood panel (5 x 5in/13 x 13cm) primed with white gesso (see page 16)
- ☐ Graphite or colored pencil
- ☐ Eraser
- ☐ Ruler
- ☐ White gesso
- ☐ Fixative spray
- ☐ Small palette knife
- ☐ Palette
- ☐ Container of water
- ☐ Paper towels
- ☐ Glazing medium (optional, can use water)
- ☐ 1-in (2.5-cm) flat brush (for wash)
- ☐ Flat brush (size 8)
- ☐ Round brush (sizes 0, 1, and 6)

SET-UP

Place the mushrooms in different positions and at varying angles to allow you to explore composition and select your favorite view. A variety of background colors would look great against the browns of the mushrooms. Even if you set up your still life against a white backdrop you can change the background color within your painting.

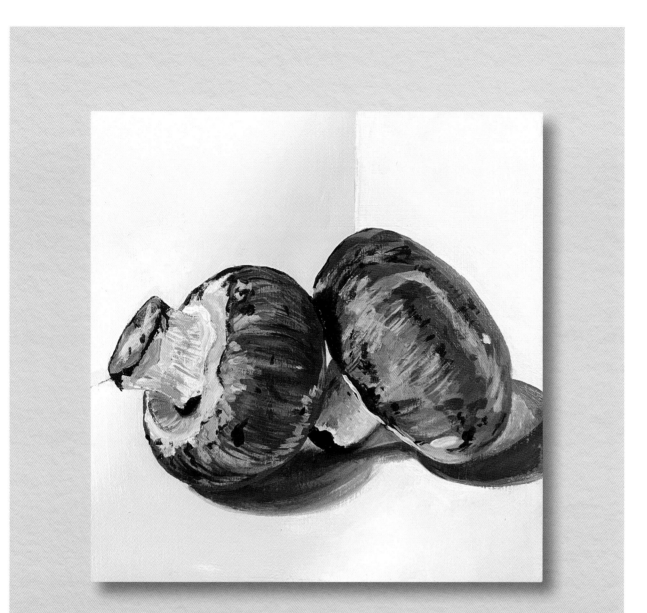

Build up the texture on the mushroom caps by layering small brushstrokes in varying sizes and colors.

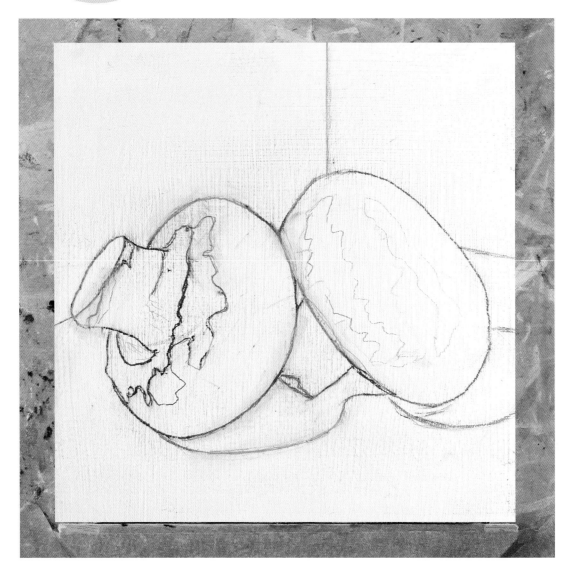

1. UNDERDRAWING

Using a graphite or colored pencil, draw the outline of the mushrooms and their cast shadows. Include any other interesting lines and prominent shapes you notice. When you are finished, fix your drawing.

TIP

It can be helpful to draw the outlines of cast shadows or shifts in color within the object itself.

2. APPLY A WASH

Apply a wash of Ivory Black using a 1-in (2.5-cm) flat paintbrush. The wash will turn more gray once the paint is diluted with glazing medium. If you prefer to skip the wash and paint directly on the white gesso background, you can.

3. PAINT BACKGROUND

To make the background color, start with Titanium White and add a bit of Cobalt Blue until you get the desired color. If it's too bright, add a tiny dot of Ivory Black.

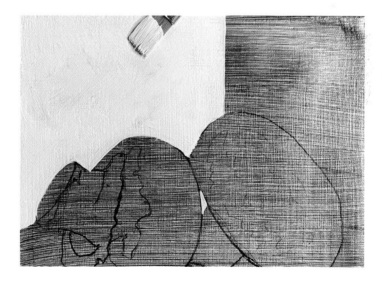

TIP

With a white backdrop, it can be fun to tint the white with a color that warms it up or cools it down. Adding a bit of Cobalt Blue to the white makes the background feel cool whereas a dot of Yellow Ochre would make it feel warm.

4. BACKGROUND CONTINUED

To paint the other side of the background, add more Titanium White to the paint mixture. Having two sides with slightly different values helps create the illusion of the mushrooms being in a space. Using a size 8 flat brush will help create a smooth line between the two values.

Note: Don't want to see the lines or edges of the backdrop? You can choose not to paint them and instead make the background a solid color.

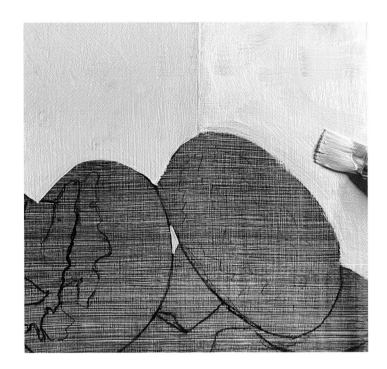

This dividing line creates a sense of space.

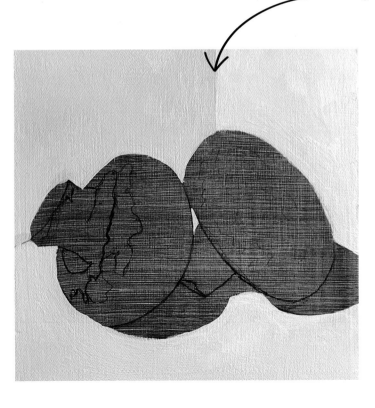

5. PAINT THE GROUND

The ground is very similar to the lighter area of the background. Using the same color or a slightly darker version (add a bit more Cobalt Blue), block in the foreground.

TIP

Build up layers with multiple coats of paint. Let each coat dry between applications for the best coverage.

6. CAST SHADOWS

Observe the cast shadows to notice the variation in value. To mix the cast shadow color, add a bit of Ivory Black to your Titanium White to make a dark gray. Add a tiny dot of Cobalt Blue. Use a size 6 round brush to apply the dark gray where the shadows are darker. Wipe your brush off, add a bit more white to the bristles, and work in the lighter values. Working quickly will allow the transitions of the values to soften and blend. You can work in layers because acrylic paint dries quickly.

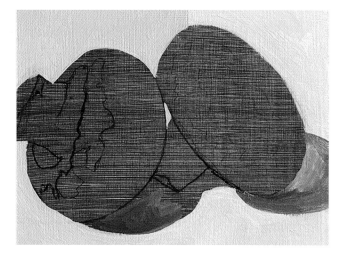

TIP
Squint your eyes to see the shifts in value more easily.

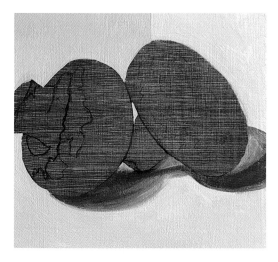

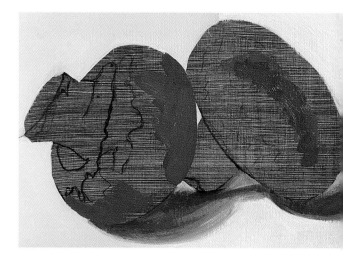

7. ADJUST VALUES

A lighter gray was added to the corner of the cast shadow on the left, in between the two mushrooms, and on the cast shadow on the right. You can always adjust the values as needed.

8. BLOCK IN MUSHROOMS

The mushrooms contain many different variations of color. Start with the local color of the mushroom caps. This was mixed using Burnt Sienna with a bit of Titanium White. Use a size 6 round brush to apply the paint. Notice the shapes that you see within the mushrooms. They don't need to be exact, just an approximation. You'll always be able to adjust later.

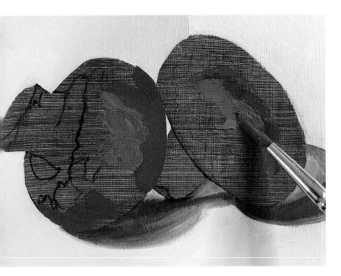

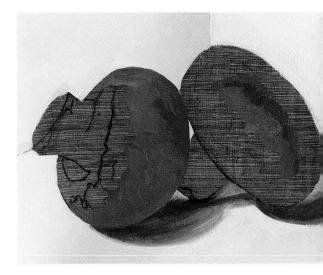

9. A SECOND COLOR

You'll work back and forth between colors as you layer and build up the paint on the mushrooms. Add in Yellow Ochre with your size 6 round brush. The first layer of paint may still be a bit wet, allowing the colors to blend together.

10. BLEND

As you block in the colors on the mushroom caps, you can use the wet-on-wet technique to create softer transitions or blends. Work back and forth between the different colors you see.

11. BLOCKING IN

To lighten the color of the mushrooms, add Titanium White, and to darken it, use Burnt Umber. Squint to see the different shapes created by the colors. It's not always easy to see defined edges, but you can use shifts in color (getting lighter or darker) as your guide. Remember, you can adjust colors as often as needed. Let layers dry and then apply new layers on top to make changes.

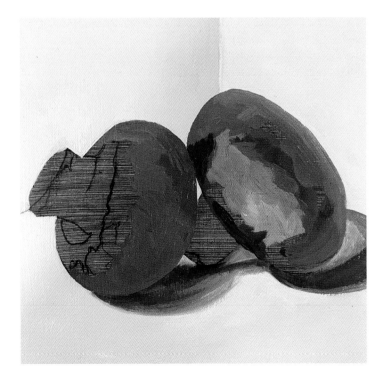

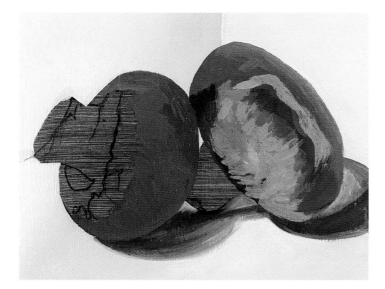

12. BUILD LAYERS

Add more layers using variations of the mixes you have already made. To warm a color, add a bit of Yellow Ochre. To lighten, add some Titanium White. Notice the direction of the brushstrokes. Are they horizontal? Vertical? Thick or thin? Paying close attention to this will help you make the mushroom caps look dimensional.

13. DARK VALUES ON STEMS

Use Burnt Umber to add the darker values on the bottom of the stems and underneath the mushroom caps.

Use a small round brush to paint in the darker values.

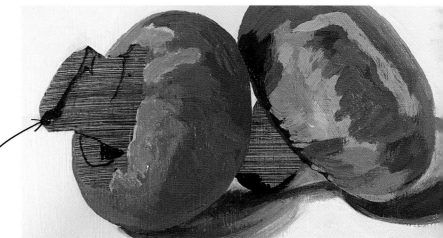

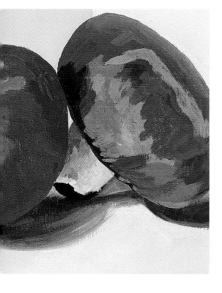

14. STEM

To paint the stem of the mushroom on the right, start with Titanium White and a tiny dot of Yellow Ochre to warm the white paint. Slowly add a bit of Ivory Black as you move toward the inside of the stem. Working quickly will allow the colors to blend, creating a soft transition. It's also okay to leave some texture here if you prefer.

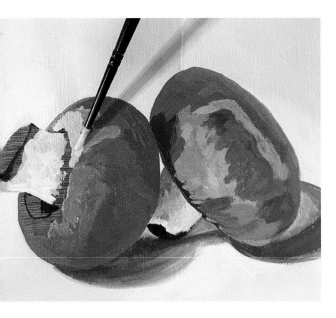

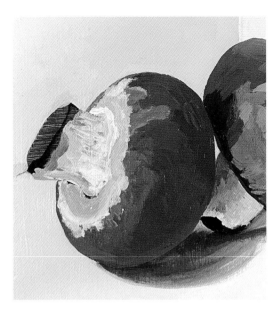

15. LIGHT VALUES

Using the same color as for the first stem, begin to block in the second stem. You'll also use this color to add in the base of the mushroom cap on the left. Use a size 1 round brush in soft, circular motions to apply the color.

16. MAKING ADJUSTMENTS

On the edge of the mushroom cap (mushroom on the left) you'll notice the inside edge is slightly darker than the outside edge. Show this in your painting by adding a bit of Burnt Sienna to the base stem color. Use this color to begin adding texture to the stem as well.

17. BOTTOM OF THE STEM

Use the color you mixed in the previous step to fill in the bottom of the stem. For the color in the middle, add a bit more white. Finally, using a size 0 round brush, take some Burnt Umber and add a few small marks to push the darkest values.

Gently scumble between the hard edges of the two colors to soften them.

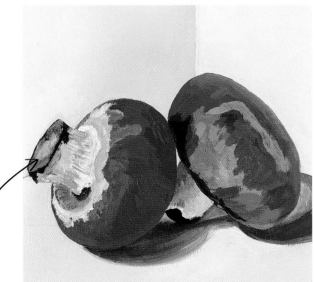

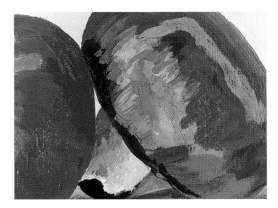

18. BUILDING TEXTURE

Continue to add small linework in varying colors to build the texture of the mushroom caps. Yellow Ochre is used straight from the tube and mixed with Titanium White to get the variations you see here. Remember to let layers dry before adding more lines on top, so they don't smudge together. Seeing the overlap of lines helps translate the texture.

19. STEP BACK AND ASSESS

Step back and take a look at your painting from a distance. Take note of the values and make adjustments as needed. Perhaps you want to darken some areas or add in more highlights? A white line was added at the bottom of the mushroom on the right as well as a small highlight. A size 0 brush was used to apply the thin line.

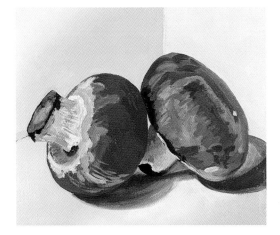

TIP

If you want to check values, try taking a picture of your painting and turning it black and white. Do you see a full range of values? If not, where can you darken or lighten the values?

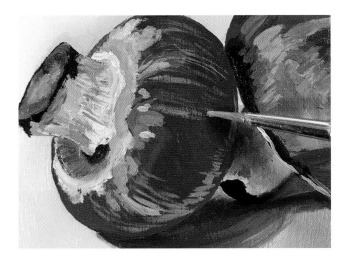

20. FINE DETAILS

Using a size 0 round brush, add some of the texture you can see on the mushrooms. To create the color variations, use white as your base and add Yellow Ochre and Burnt Sienna as needed, adjusting these values as you go. Remember that you don't have to include every single detail but rather an expression of what you see. Use small, quick strokes to create the texture.

RADISH

A radish is a fun and challenging subject. The bright red of the radish complements the green of the leaves, and the movement between the leaves, radish, and stem makes for an interesting composition. The cast shadow is dramatic and dark, which allows the radish to come forward.

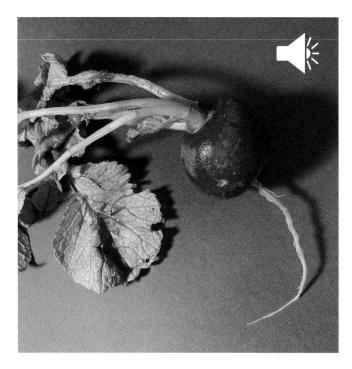

SET-UP

Set the radish against a simple background. You could work with a light or dark background, though the darker background here makes the red of the radish pop. Experiment with a directional light source to create cast shadows. Cast shadows are often as interesting as the subject matter!

PAINT COLORS

- ■ Phthalo Blue
- ☐ Titanium White
- ■ Cadmium Red Medium
- ▨ Yellow Ochre
- ☐ Lemon Yellow
- ▨ Emerald Green
- ▨ Viridian Hue Permanent
- ■ Ivory Black

TOOLS AND MATERIALS

- ☐ Wood panel (5 x 5in/13 x 13cm) primed with white gesso (see page 16)
- ☐ Graphite or colored pencil
- ☐ Eraser
- ☐ Ruler
- ☐ White gesso
- ☐ Fixative spray
- ☐ Small palette knife
- ☐ Palette
- ☐ Container of water
- ☐ Paper towels
- ☐ Glazing medium (optional, can use water)
- ☐ 1-in (2.5-cm) flat brush (for wash)
- ☐ Flat brush (size 8)
- ☐ Round brush (sizes 0, 1, and 6)

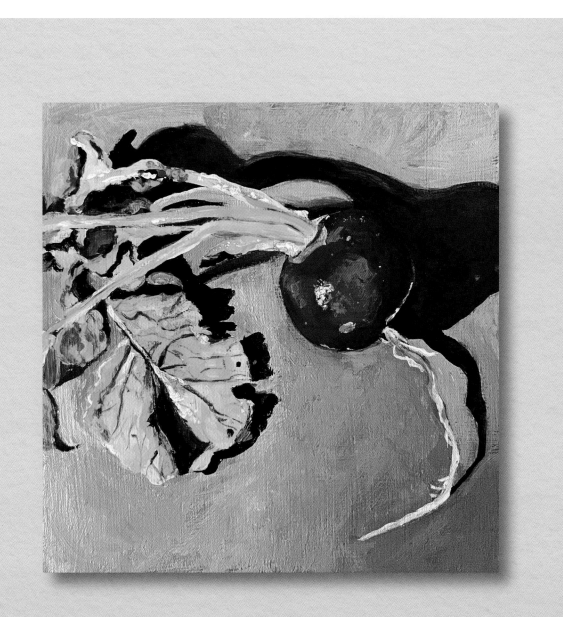

This cast shadow is
very dramatic. If you
prefer a softer shadow, try
placing a secondary light
source on the radish.

1. UNDERDRAWING

Using a graphite or colored pencil, draw the outline of the radish and its cast shadows. Look at the other lines and shapes you notice. How much detail you want to include in your drawing is completely up to you. When you are finished, fix your drawing.

Note: When you erase on the gessoed wood panel it can sometimes leave behind graphite smudges. Continuing to erase will lift them up, but the acrylic paint will completely cover everything over if there are some smudges left behind.

2. APPLY A WASH

A 1-in (2.5-cm) flat paintbrush was used to apply a wash on the wood panel. The wash here was created with a bit of Yellow Ochre and a glazing medium, but your wash can be any color.

Note: If you prefer to begin your painting on the white panel, you can skip the wash step and move on to painting the background.

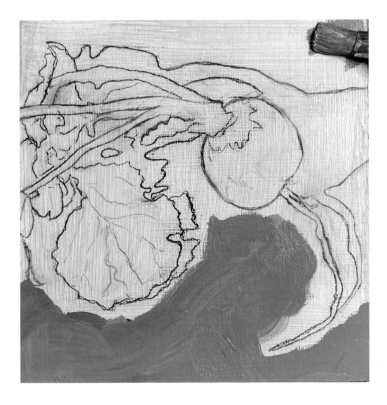

3. PAINT BACKGROUND

To make the background color, start with Titanium White and add a bit of Phthalo Blue. Mix in a dot of Ivory Black. Use the size 8 flat brush to block in the background. You may want to switch to a smaller brush as you cut into the areas within the leaves and root.

Note: Some artists begin with the background and then paint the subject matter, while others start painting the subject matter first and then cut in the background. You can always start with step 7 and then return to steps 3–6 if you prefer.

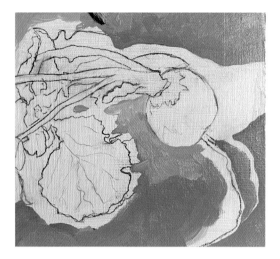

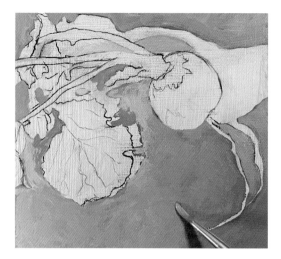

4. BUILD LAYERS

The background color here was slightly lightened with the addition of some white and a second coat was added to the painting. Acrylic paint can be built up in layers, letting each layer dry in between. This creates opaque coverage.

5. SCUMBLE BACKGROUND

Here, a size 6 round brush was used to gently apply the second layer of paint using a scumbling technique (see page 28). This technique allows the paint to appear soft and hides the appearance of any directional brushstrokes. Colors can always be adjusted if you want. Add more white to lighten the color or more black to darken it.

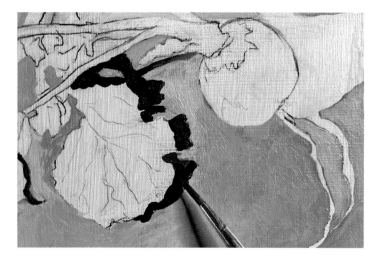

6. CAST SHADOWS

To make the cast shadow color, add more Ivory Black to the color you used for the background. Use the size 6 round brush to paint in the cast shadow. It may be helpful to size down to a smaller round brush as you fill in smaller areas. Pay attention to areas where the background color pokes through the cast shadow due to tiny holes in the leaves.

TIP

Notice the subtle variations in the color of the cast shadow. You can add more white or more black to create these different values.

Leave some of your brushstrokes visible for a more expressive style.

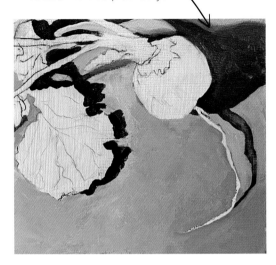

7. ADJUST VALUES

Along the cast shadow of the root there is a lighter value. (You can see this lighter value at the top of the cast shadow of the stem as well.) Add white to the cast shadow color and use a size 0 round brush to paint it in. If you want to blend the cast shadow colors, you'll need to use the wet-on-wet technique (see page 26).

TIP

If you want soft transitions between your values, you'll need to work quickly, since acrylic paint dries so fast. You can always add a bit of retarder medium to your acrylic paint to slow down the drying time. Work your paintbrush between the different values to soften the transition.

8. BLOCK IN THE RADISH

Use Cadmium Red Medium on a size 6 round brush to block in the midtone values of the radish. Look for the shapes that you see. You can always adjust later as needed.

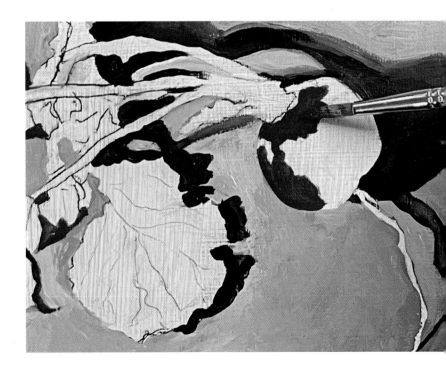

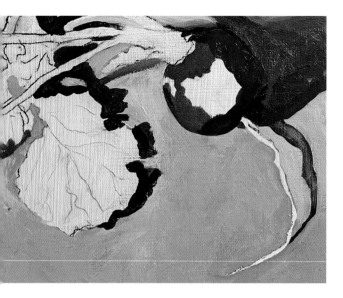

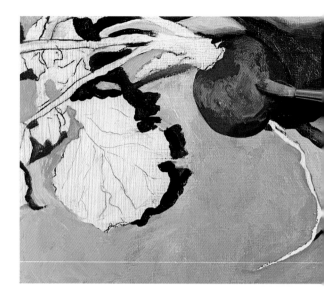

9. DARK VALUES

To darken the Cadmium Red, add a dot of Viridian Hue Permanent. Look for the areas in the radish where you see dark values and paint them in. You may have to go back and forth between your midtone reds and darker reds.

10. GAUGING VALUES

Squinting at your subject will make it easier to see variation in the values. Add some white to the Cadmium Red to lighten it. Look for areas where you can see lighter values and paint them in. Add your darker values again as necessary.

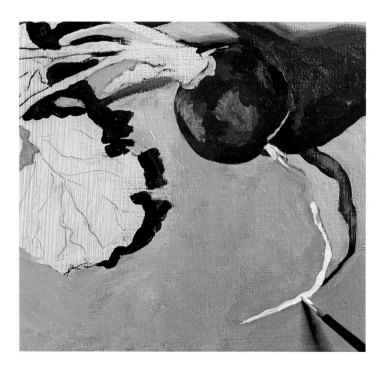

11. THE ROOT

There are multiple colors on the root, ranging from white, to a bit of yellow, to a lighter red. To make the light red, add Titanium White to Cadmium Red. Use a size 0 round brush to paint the root. Use Titanium White to add a small bit of reflected light at the bottom of the radish.

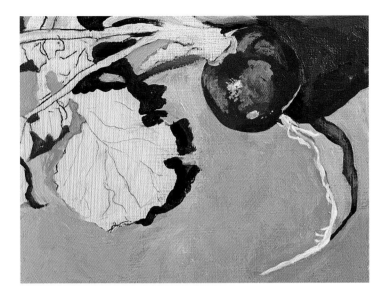

12. DETAILS OF THE ROOT

Look closely and observe the details of the root. There are subtle color variations and small, organic lines coming out from the root. Using your smallest round brush, paint the small details of the root. Here, tiny highlights were also added to the radish. Some of the highlights are pure white whereas the lower highlight has a tiny bit of Cadmium Red added to it.

TIP

There are several methods for adjusting the green for the leaves. For the darkest greens you'll want to use Viridian Hue Permanent and add a bit of Ivory Black. For the medium greens you'll use Emerald Green, adding a bit of Cadmium Red to darken it.

There are various greens within the leaves.

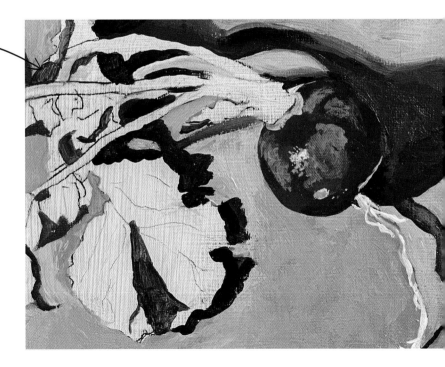

13. PAINT THE LEAVES

Look for the darker values in the leaves and start by blocking them in. Use whichever brush fits best in the area you are painting. Work back and forth between your small round brushes (sizes 0 and 1) and a size 6 round brush.

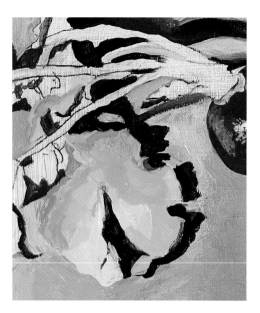

14. WORK BETWEEN VALUES

Use Lemon Yellow to lighten the green of the leaves. For the lightest values, also add some Titanium White. It's easiest to work back and forth between the different values of green, especially since the colors overlap and intersect in different areas. Look for the different shapes you see and remember it's an approximation. Don't worry about being exact.

TIP
This isn't painting by numbers; you can allow your brushstrokes to overlap.

Add darker strokes between the stems.

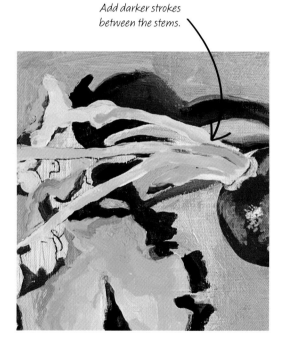

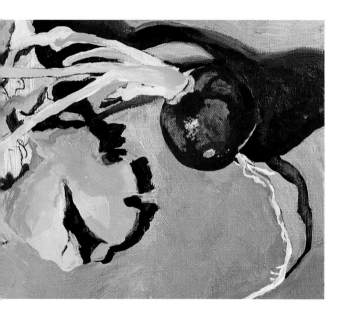

15. PAINT THE STEM

Many of the greens you used to paint the leaves are also found in the stem. Look for areas of darker green and paint those first, then fill in the lighter values of green. This will allow you to see the different areas of the stem without it all blending together.

16. DETAIL ON STEM

Add a bit of Yellow Ochre to capture some of the detail on the stems using a size 0 round brush to add a few small strokes. Finish the last bit of the leaves, varying the greens as you did before.

17. LEAF VEINS

Use your size 0 brush to add some small lines to create the veins on the leaf in the front. The color of the veins varies just as it does in the leaves. Use some of the same greens you mixed for the leaf for the veins. Notice where they are darker and where they're lighter.

Layer the green to build up the opacity.

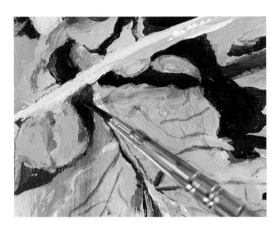

18. PUSHING VALUES

As you step back and assess your painting, take note of any areas where the values could be pushed even darker. Darker values go back in space and lighter values come forward. Together they create a sense of depth. Here, the darkest greens of the leaves were pushed even darker to accomplish this.

19. DETAIL WORK

Using my smallest brushes, I look for areas where I can add any final details to the painting. Remember, you don't need to include every single detail you see but including a few can make the painting come together.

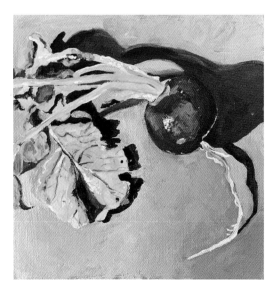

BELL PEPPER

Peppers come in orange, yellow, red, or green. This orange pepper will be a fun color challenge. Capturing the smooth texture of the pepper requires wet-on-wet blending with the acrylic paint. Adjusting the background to more of a blue would create a complementary contrast to the orange of the pepper.

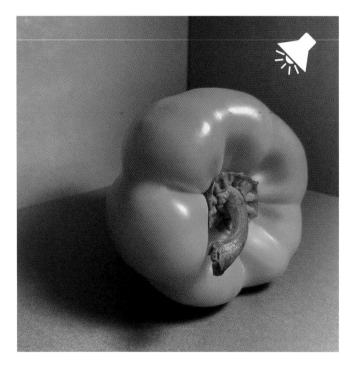

SET-UP
Placing the orange pepper against a darker background creates more contrast. Experiment with a directional light source to create interesting cast shadows. Keep in mind when painting that you can choose to change colors, either drastically or subtly.

PAINT COLORS
- ◼ Ultramarine Blue
- ◼ Mars Black
- ☐ Titanium White
- ◼ Cobalt Blue
- ◼ Burnt Umber
- ◼ Viridian Hue Permanent
- ☐ Lemon Yellow
- ◼ Cadmium Red
- ◼ Burnt Sienna

TOOLS AND MATERIALS
- ☐ Wood panel (5 x 5in/13 x 13cm) primed with white gesso (see page 16)
- ☐ Graphite or colored pencil
- ☐ Eraser
- ☐ Ruler
- ☐ White gesso
- ☐ Fixative spray
- ☐ Small palette knife
- ☐ Palette
- ☐ Container of water
- ☐ Paper towels
- ☐ Glazing medium (optional, can use water)
- ☐ 1-in (2.5-cm) flat brush (for wash)
- ☐ Flat brush (size 8)
- ☐ Round brush (sizes 0, 1, and 6)

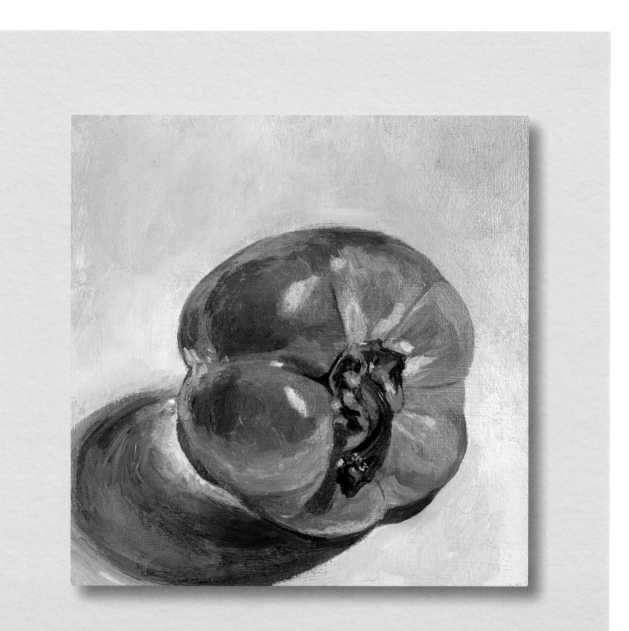

You can choose to have visible, expressive brushstrokes in your painting or you can blend them smooth.

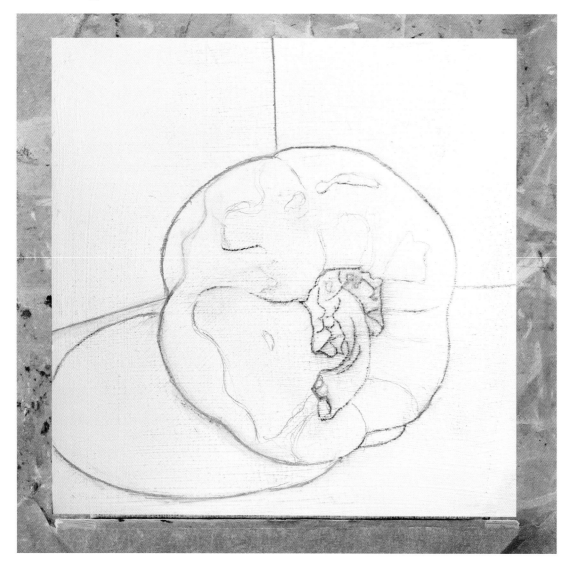

1. UNDERDRAWING

Draw the outline of your pepper and its cast shadow using a graphite or colored pencil. Look at the other lines and shapes you notice and include any you find interesting. When you are finished, fix your drawing.

Note: The lines indicating the edges of the backdrop are included in this sketch, but you can remove them later if you prefer.

2. APPLY A WASH

A Burnt Sienna wash was applied here using a 1-in (2.5-cm) flat paintbrush. A wash can be any color and it provides a ground and a middle value for you to start painting on. Glazing medium was used to dilute the paint and make it transparent.

Note: Acrylic mediums, such as glazing medium, are made of the same acrylic resin found in your paint—it just has no pigment, so it keeps the formula strong and archival.

TIP

The addition of more blue and less gray will complement the orange of the pepper. Remember, you can make the background any color you want, regardless of your still-life backdrop. It can be fun to play with color schemes, such as complementary colors, in a painting.

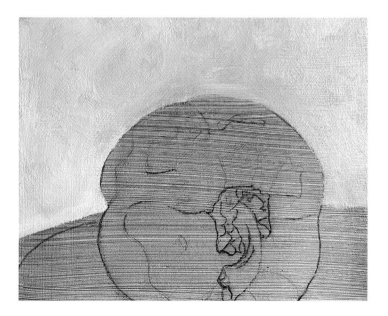

3. PAINT BACKGROUND

Mix the background color using a base of Titanium White with a bit of Cobalt Blue and a small dot of Burnt Umber. As you paint the background you can add more white to lighten your base color. This gives the background some variation instead of it being a flat color. A size 8 flat brush was used here to apply the paint.

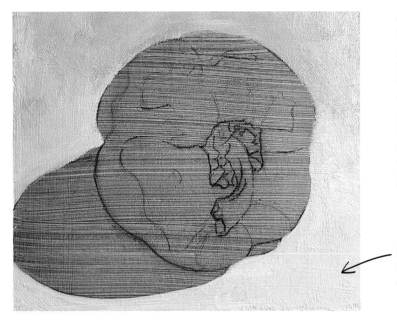

4. PAINT THE GROUND

I made the decision here to remove the edges of the backdrop. I added white to the background color in order to create the color for the ground. Use a size 8 flat brush to paint the ground. To create a soft blend here, utilize the wet-on-wet technique (see page 26).

While still wet, use a flat, dry brush to softly blend the blue and white together.

TIP

If you prefer to see the edges of the backdrop, use a size 0 round brush and a slightly darker version of the background color to paint a thin line.

5. CAST SHADOW

The cast shadow is a range of grays, with the darkest part of the shadow closest to the viewer. Mix gray with Titanium White and Ivory Black. The more black you add, the darker the gray will be. You may have to experiment with the ratios, but always start with a small amount of black. Mix in a tiny bit of Cobalt Blue to bring in the color from the background. Use a size 6 round brush to block in the dark and light areas of the cast shadow.

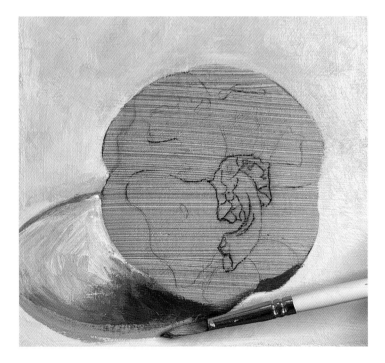

6. DARKEN AND BLEND

Using the size 6 round brush, push the dark values that you see. To blend, work wet on wet to allow the edges of the different values to soften. Squint at the cast shadow to better see the variation between the lighter and darker values. You can always make adjustments if needed.

7. MIDTONES

Start by blocking in the local color or middle value of the pepper. Take a base of Lemon Yellow and slowly add a bit of Cadmium Red until you get an orange. Use the size 8 flat brush to start blocking in the midtone oranges.

TIP

Yellows and oranges are often more transparent than other acrylic paint colors. Add a small dot of Titanium White to the orange and mix thoroughly to increase the opacity of the paint.

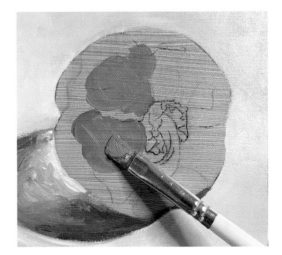

8. DARKER VALUES

Start with your midtone orange from step 7 and mix in a dot of Cobalt Blue to darken it. You will only need a tiny dot, so don't overdo it. Use your size 6 round brush to block in the darker values where you see them. If you need to return to the midtone orange, you can. It can be helpful to go back and forth between the different values as you layer the paint on your painting.

Note: *There are various methods for darkening orange. First, you can darken with the complement (in this case, Cobalt Blue), or you can use a bit of Burnt Sienna. You may also choose to darken your orange with Ivory Black, but be careful, because a little will go a long way.*

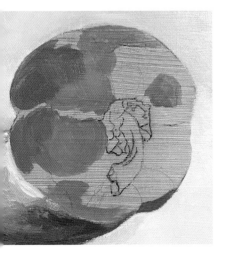

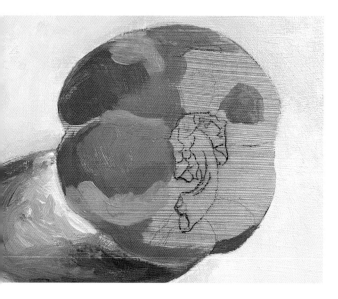

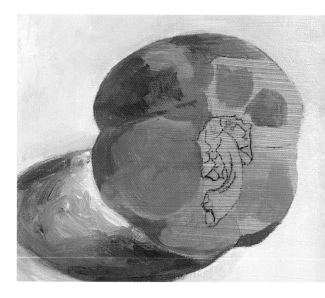

9. LIGHTER VALUES

To create the lighter values, add Titanium White to the midtone (local color) orange. Apply the lighter values using whichever brush feels the best for you.

10. SEARCH FOR SHAPES

Squint and search for the shapes within the pepper. You can find shapes by looking at the edges between shifts in color or value. You can always adjust your painting as you go. The acrylic paint will dry quickly, allowing you to make any corrections by simply painting over anything you want to change.

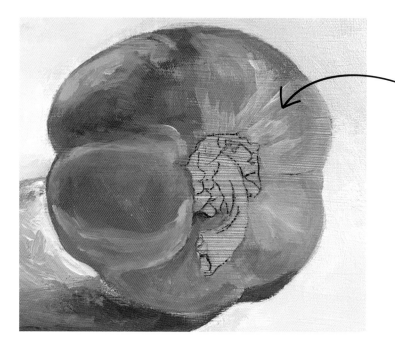

Directional brushstrokes create a three-dimensional effect.

11. BUILDING LAYERS

Continue to block in the pepper, paying attention to the shifts in color values. Here, lighter values were added with a size 1 round brush to start to push the curves we see in the pepper.

12. THE STEM

To make the lighter green in the stem, mix Viridian Hue Permanent with Lemon Yellow. Then, add a small dot of Titanium White. Use your size 0 round brush to block in the areas where you see the lighter green color. Keep in mind that you don't have to paint every single detail you see.

13. DARKER STEM VALUES

Mix some Viridian with a dot of Cadmium Red to create a darker green color. Repeat the process you followed with the lighter values. Focus on the lines and shapes that you see in this dark green color. Feel free to add in more of the light value as needed. It can be helpful to go back and forth to build up layers.

14. WORK BETWEEN VALUES

A couple more variations of green were added to the stem to make the detail stand out just a bit more. Add an even darker variation of green by mixing a bit of Ivory Black into it. Notice on the stem where it's darkest and fill in those values. For the lighter areas or highlights, mix Viridian with Lemon Yellow. You can adjust how much white you add to make it lighter.

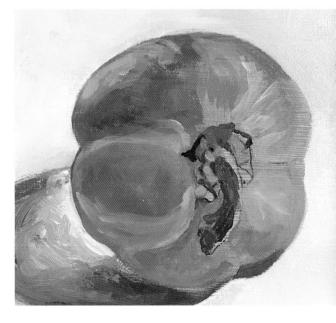

TIP

While white does make colors lighter, it doesn't make them brighter. Try mixing Lemon Yellow into the Viridian. Then mix white into the Viridian. What do you notice?

15. PUSHING VALUES

To really push the form, paint over the darker values with a slightly darkened version of the color. This includes some of the thin lines between the sections in the pepper. Use a size 0 round brush with a tiny bit of water on it to achieve these thin, smooth lines.

TIP
Add a few highlights to the stem.

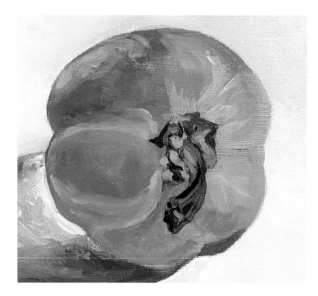

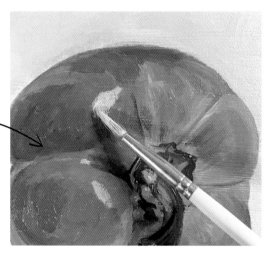

Darkening some areas makes the highlights look more realistic.

16. HIGHLIGHTS

Not all highlights are pure white. Start with the highlights that are tinted slightly. To create this color, take a base of Titanium White and add just a dot of your midtone orange, mixing thoroughly. Use a size 6 round brush to paint in the areas of highlights around the pepper.

17. HIGHLIGHTS CONTINUED

After the first layer of paint for the highlights has dried, grab your pure white paint and add a few areas of really bright highlights.

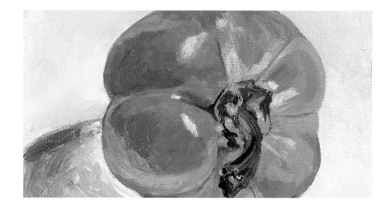

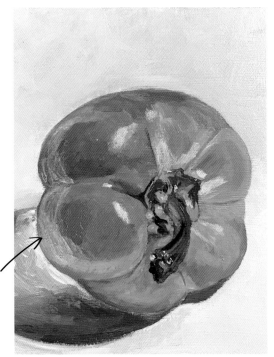

18. GLAZE

Using some glazing medium and Titanium White, paint in the reflected light on the left of the pepper using your size 6 round brush.

Glazing makes the paint more transparent.

19. GLAZE IN CAST SHADOW

Mix some glazing medium with the midtone orange to create a transparent color. Add a bit of black to darken the glaze mixture, then add in the orange reflection you can see in the cast shadow.

Note: You may want to adjust areas of the cast shadow or soften the edges. Using a size 6 round brush with just a little bit of paint on it, gently apply the paint to the edge of the cast shadow.

Note the range of values in this cast shadow.

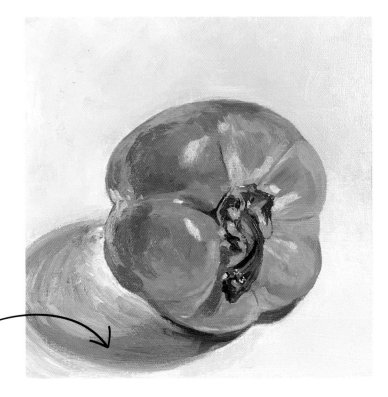

GREEN LEAVES

Items from nature can make great subject matter for painting. These green leaves create an exciting composition because even though the leaves are similarly shaped, they are seen from different angles and have a variety of values and shades of green. I was really interested in the cast shadows that the leaves created after I turned on a directional light source.

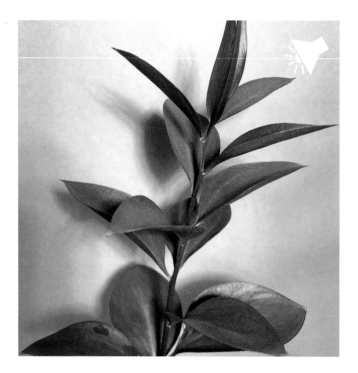

SET-UP

Place the green leaves against a light tan-colored matboard with a directional light source coming from the upper right. A light-colored background really brings out the cast shadows, but you can easily change the background color if you want to. Take several photographs to experiment with composition.

PAINT COLORS

- ◼ Burnt Sienna
- ◼ Mars Black
- ☐ Titanium White
- ◼ Yellow Ochre
- ◻ Lemon Yellow
- ◼ Cobalt Blue
- ◼ Phthalo Green

TOOLS AND MATERIALS

- ☐ Wood panel (5 x 5in/13 x 13cm) primed with white gesso (see page 16)
- ☐ Graphite or colored pencil
- ☐ Eraser
- ☐ Ruler
- ☐ White gesso
- ☐ Fixative spray
- ☐ Small palette knife
- ☐ Palette
- ☐ Container of water
- ☐ Paper towels
- ☐ Glazing medium (optional, can use water)
- ☐ 1-in (2.5-cm) flat brush (for wash)
- ☐ Round brush (sizes 0 and 6)

The looser the application of paint and brushwork, the more expressive your painting will be.

1. UNDERDRAWING

Using either a graphite or colored pencil, draw the outline of the leaves and their cast shadows. Look at the other lines and shapes you notice and include the most prominent ones in your drawing. When you are finished, fix your sketch with the spray.

2. APPLY A WASH

This wash was applied with Burnt Sienna using a 1-in (2.5-cm) flat paintbrush. Don't worry if you can see some brushstrokes. Let the wash dry before continuing with your painting.

TIP

A wash provides a middle value for you to start painting on, which can feel less daunting than beginning on a white surface. Plus, it allows you to easily see dark and light values as you begin to block in your painting.

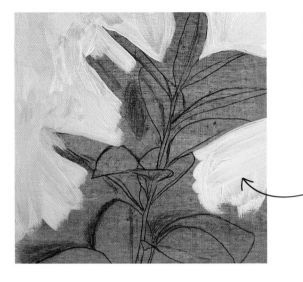

3. BLOCK IN BACKGROUND

Start blocking in the background using a mix of Titanium White and Yellow Ochre. Allow your brushstrokes to overlap in varying directions for a more expressive application of paint.

Vary the directions of brushstrokes.

4. BLEND IN COLOR

Using a mix of Titanium White and a bit more Yellow Ochre, blend in some of the color using a size 0 round brush.

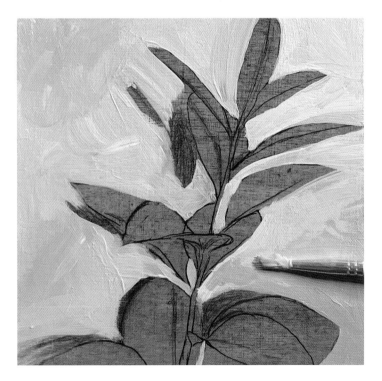

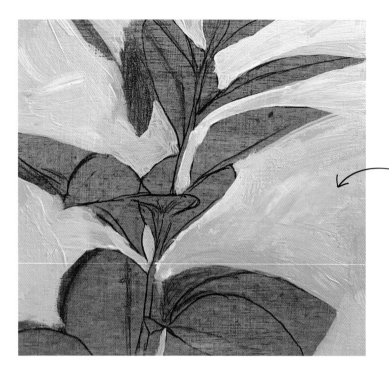

5. BUILDING LAYERS
Continue to blend the Yellow Ochre mixture into the background.

Build layers of paint to increase opacity.

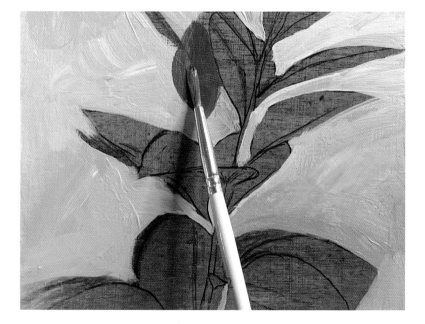

6. CAST SHADOWS
Paint the cast shadows of the leaves using a size 6 round brush. To create the color, start with your background color and add a bit of Mars Black to darken it.

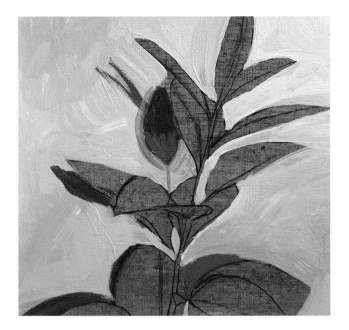

7. GLAZING

Continue to paint the cast shadows of the leaves. For areas where the shadows are lighter, mix in a bit more Titanium White to lighten the color. Glazing medium can be mixed into the paint for areas where the shadows are softer and feel more transparent.

TIP

Step away from your work and look at it from a distance a few times throughout the process. This will help you assess if there are any adjustments that you need to make.

8. DARK VALUES

Block in the dark values within the stem and the leaves. Mix Phthalo Green with a bit of Mars Black to get the darkest value.

Scumble the edges of the shadow with the brush to achieve a soft edge.

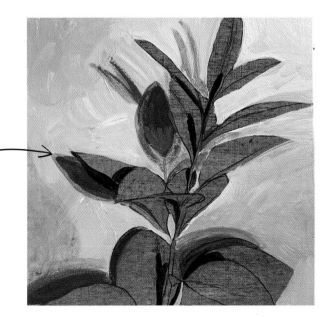

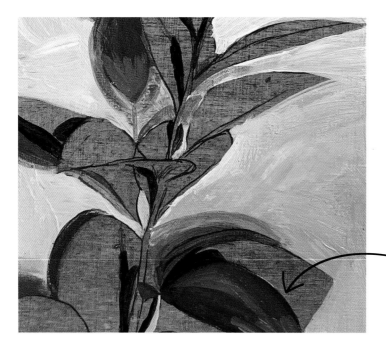

9. MIDDLE VALUES

Block in the darker and medium values within the leaves. Remember that you can always make adjustments to the colors as needed.

Differentiate between the leaves by including different values in the greens.

10. MOVING AROUND THE PIECE

Move around the painting and block in various greens, allowing yourself to hop between medium to light values of green. I like this method of painting because it can create interesting layers and an overlap of brushstrokes.

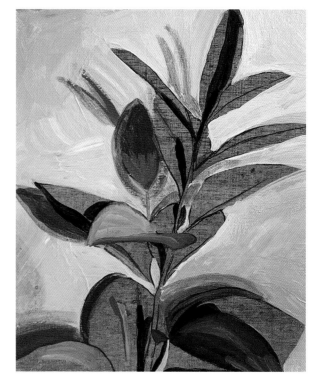

TIP
Add Lemon Yellow to make your green lighter and brighter.

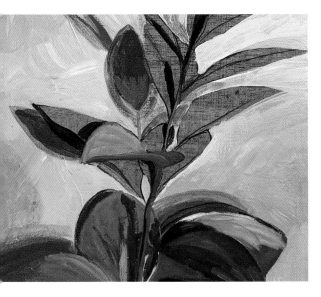

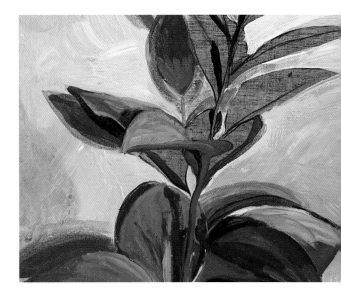

11. OBSERVE VALUES

Continue to block in the leaves and stem. Observe the reference and notice how the different values of green work together to create a sense of depth. Darker values push back in space, while lighter values come forward.

12. BLOCKING IN

I often squint at my reference to blur out the details and focus on the value structure, allowing me to notice the shapes each value of green creates. Paint a loose suggestion of these shapes within the leaves, building up the value.

13. BUILDING LAYERS

Continue to add layers of paint, building coverage over the entire surface of your painting. Step back frequently to assess your progress.

Adjust colors or values as you see fit.

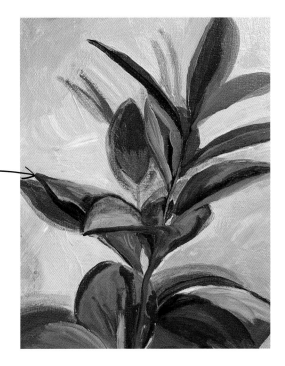

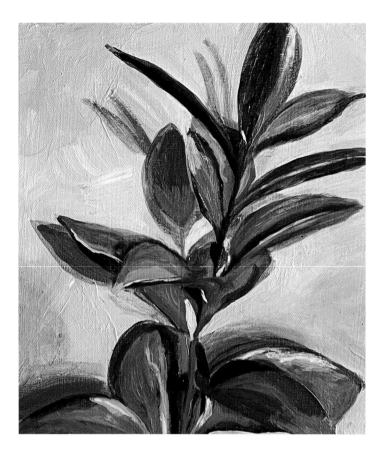

14. MAKING ADJUSTMENTS

After most of the leaves are blocked in, refine the edges and add more detail. Acrylic paint dries quickly, so you can easily adjust values as needed.

15. HIGHLIGHTS

Mix Cobalt Blue into the Titanium White to create the highlights on some of the leaves. Using a size 0 round brush, loosely paint in the shapes that you see.

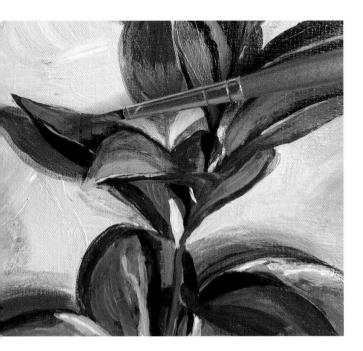

16. PUSHING VALUES

As you build up layers, look for areas in the painting where you can push values either darker or lighter. This creates more contrast and depth in a piece.

Textured background created by varying direction of brushstrokes.

17. BLEND BACKGROUND

If you want to make the background lighting more dramatic, blend a mix of Titanium White with a dot of Yellow Ochre and scumble some of the paint into the upper left of the composition.

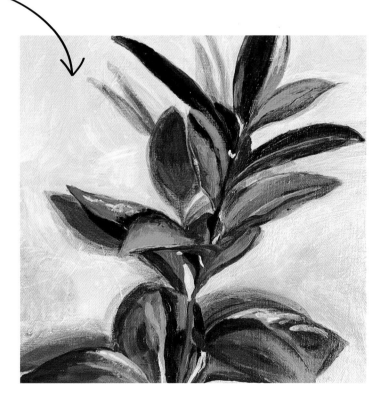

GLASS OF WATER

A glass of water can be a fun challenge and not as complex as you might think. Pay attention to the color you put behind the glass as it will poke through in areas within the glass. As you observe the glass of water, you'll start to see the reflections as simple shapes. I often squint at my subject to blur out the small details and focus on the value structure.

PAINT COLORS

- Yellow Ochre
- Ultramarine Blue
- Mars Black
- Titanium White

TOOLS AND MATERIALS

- Wood panel (5 x 5in/13 x 13cm) primed with white gesso (see page 16)
- Graphite or colored pencil
- Eraser
- Ruler
- White gesso
- Fixative spray
- Small palette knife
- Palette
- Container of water
- Paper towels
- Glazing medium (optional, can use water)
- 1-in (2.5-cm) flat brush (for wash)
- Flat brush (size 8)
- Round brush (size 0)

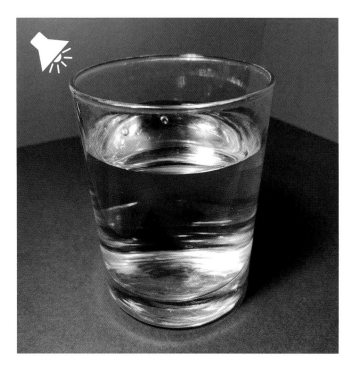

SET-UP

Place the glass of water on a blue matboard with a directional light source coming from the front left. Move the light around to experiment with the cast shadows on the glass, and once you find the composition with the shadows and highlights that interest you the most, make a quick sketch before starting your painting.

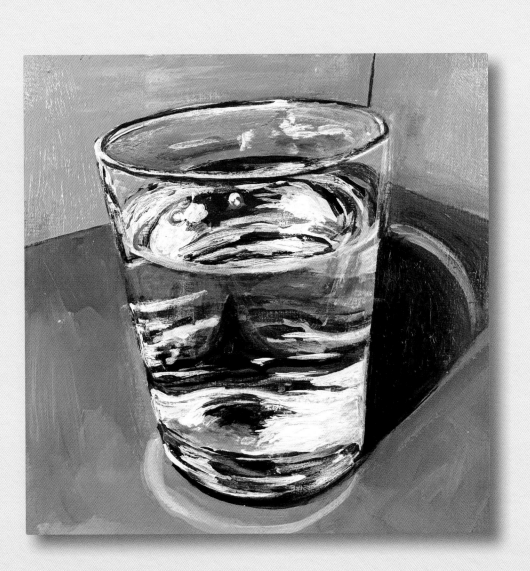

Adding glazing medium to your paint will allow you to capture the reflections within the glass.

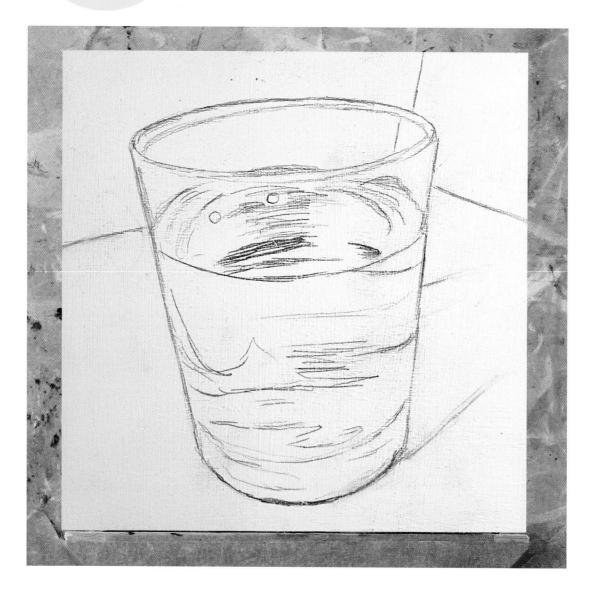

1. UNDERDRAWING

Using either a graphite or colored pencil, draw the outline of your glass and its cast shadows. When you are finished, fix your drawing.

2. APPLY A WASH

Selecting a Yellow Ochre wash for this painting will provide a warm contrast to all of the cool blues. Use a 1-in (2.5-cm) flat paintbrush to apply the wash and let it dry before you begin painting.

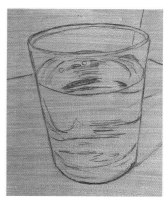

3. PAINT BACKGROUND

I like to work back to front when I am painting, although sometimes I will paint the subject first. I used a size 8 flat brush to apply this background—the color is Titanium White mixed with a little bit of Ultramarine Blue.

TIP

Don't worry too much about color matching. Focus on the value structure and mix a color that is a similar value.

4. CAST SHADOW

With a size 8 flat brush, start blocking in the cast shadow using Mars Black mixed with a bit of Ultramarine Blue. Use a size 0 round brush to add the thin reflection line to the corner of the background.

TIP

Your blend could be smooth, or it could include some interesting texture.

5. BLEND THE CAST SHADOW

Use your brush to work in variations of the color (add Titanium White to lighten and Mars Black to darken). You'll want to work quickly, utilizing the wet-on-wet technique to achieve a blend.

TIP

Let your paint dry fully between layers, as this will allow you to build up the opacity of the paint.

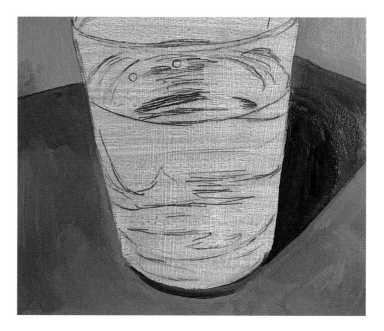

6. PAINT THE GROUND

To get the color for the ground, mix Ultramarine Blue with a bit of Mars Black. It should be darker than the background color. Use a size 8 flat brush to lay in the color. Acrylic paint is fairly opaque, but it can require multiple layers to achieve the desired look.

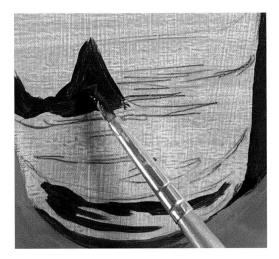

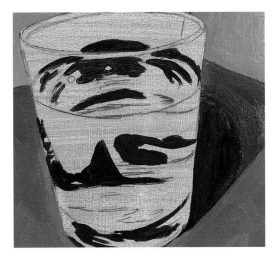

7. BLOCK IN DARK VALUES

Block in the darkest values within the glass of water, looking for the shapes that the glass creates. It's okay if your shapes are slightly different from the reference. Squinting to blur out the details can make it easier to notice the contrast between values.

8. LOOK FOR SHAPES

Continue to block in the darkest values. Focus on the shapes that are most prominent—you don't need to include every detail.

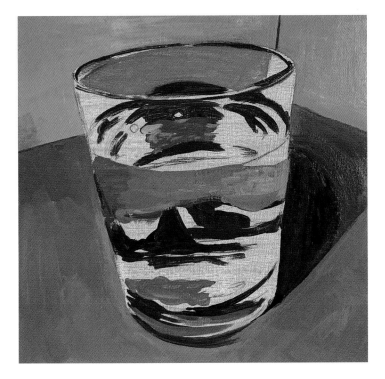

9. BLOCK IN MEDIUM VALUES

Start to block in the medium values. Keep in mind this isn't just one shade of blue: there are slight variations within the color. Squint at the reference photo to blur out the details and make the values easier to see. You can work on a different area of the painting while you let an area dry.

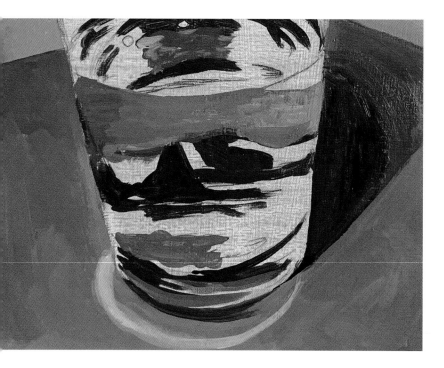

10. GLAZE IN REFLECTIONS

Using a round brush, add a bit of glazing medium (or water) to some white paint, then add a small bit of Ultramarine Blue. Look at the shapes created by the reflection around the bottom of the glass and then paint them in. The glazing medium will create a transparent effect.

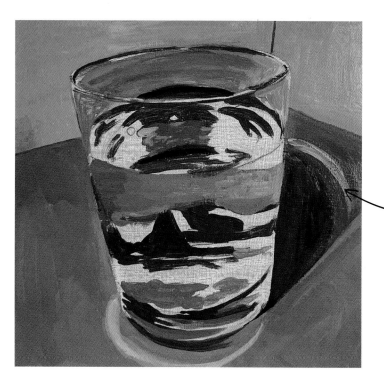

11. BUILDING VALUES

Continue to block in the values within the glass. As your paint dries, make adjustments as needed.

Highlight on surface from light shining through the glass.

12. LIGHT VALUES

Block in the highlights within the glass, repeating the process that you used to paint the medium and dark values.

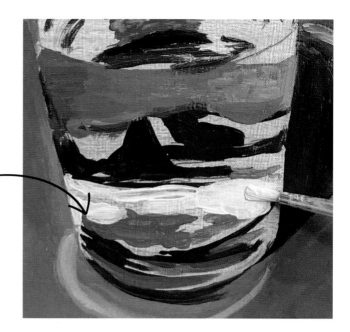

Identify shapes within the glass by looking for variation in color.

13. BLOCKING IN HIGHLIGHTS

Continue to block in the highlights within the glass. It's okay if the shapes aren't exact. Remember to squint your eyes to blur out the details and to focus on the value structure of the glass.

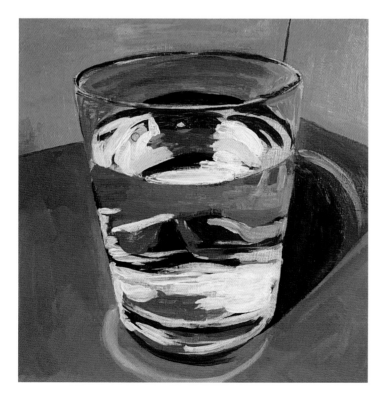

Add a couple of layers of paint to make the white more vibrant.

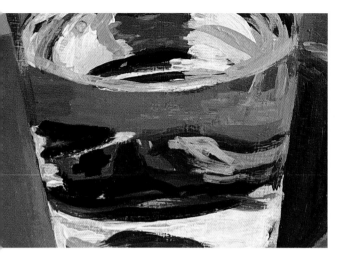

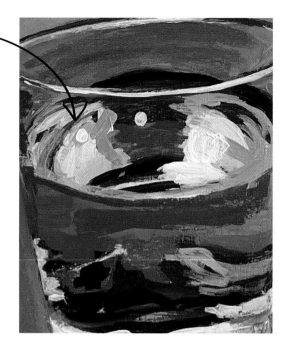

14. VARIATION

Continue to add a variation of values within the glass. You can hop around between different values as you need to. I like to allow my brushstrokes to overlap to create layers.

15. PAINT THE BUBBLES

Add smaller pops of highlights (bubbles) within the glass. Use your smallest paintbrush to do this. If you look closely, you'll notice really bright white areas within the bubbles, but also a thin dark line.

16. MAKING ADJUSTMENTS

As you are painting, you may notice things you want to change—that's perfectly fine! It's all part of the process, and you can make adjustments as needed. This can include making an area darker or lighter, or changing a color completely. Acrylic paint is very forgiving due to its quick dry time and opaque coverage.

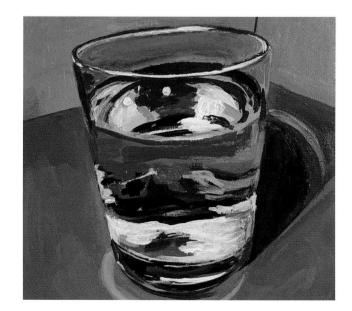

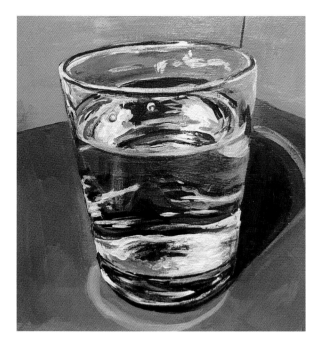

17. DETAIL WORK

Using your smallest brush, look for areas where you can add more detail to really make the painting come together, such as making a highlight pop with an extra coat of pure white or adding a hint of yellow. Remember, you don't need to include every single detail but adding a few can really enhance your painting.

Create soft edges by using less paint on your brush and less pressure on your stroke.

18. PUSHING VALUES

I always like to step back to assess my painting and push a few values before calling it finished. Making a few darker values even darker allows them to recede back in space, while adding a few pops of pure white to the brightest highlights allows them to come forward. Here, I also decided to brighten the blue in the background and within the glass itself.

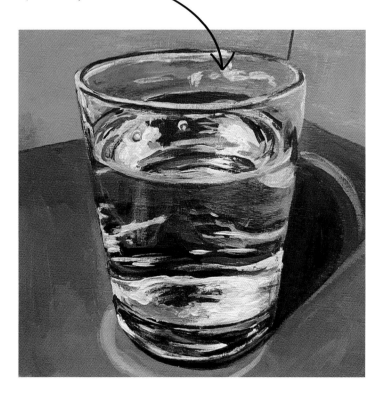

SPOONS

Spoons are highly reflective, full of varying lights and shadows. Placing two spoons within the frame makes the composition interesting. The yellow background here adds contrast to the darker values of the spoons.

PAINT COLORS

- ■ Cobalt Blue
- ☐ Titanium White
- ▫ Lemon Yellow
- ▨ Yellow Ochre
- ■ Ivory Black

TOOLS AND MATERIALS

- ☐ Wood panel (5 x 5in/13 x 13cm) primed with white gesso (see page 16)
- ☐ Graphite or colored pencil
- ☐ Eraser
- ☐ Ruler
- ☐ White gesso
- ☐ Fixative spray
- ☐ Small palette knife
- ☐ Palette
- ☐ Container of water
- ☐ Paper towels
- ☐ Glazing medium (optional, can use water)
- ☐ 1-in (2.5-cm) flat brush (for wash)
- ☐ Round brush (sizes 0, 1, and 6)

SET-UP

Select a backdrop color for your composition and place the spoons overlapping each other. Position a directional light source and turn off any overhead lighting if possible. Experiment with different points of view, such as from slightly above, as I have here.

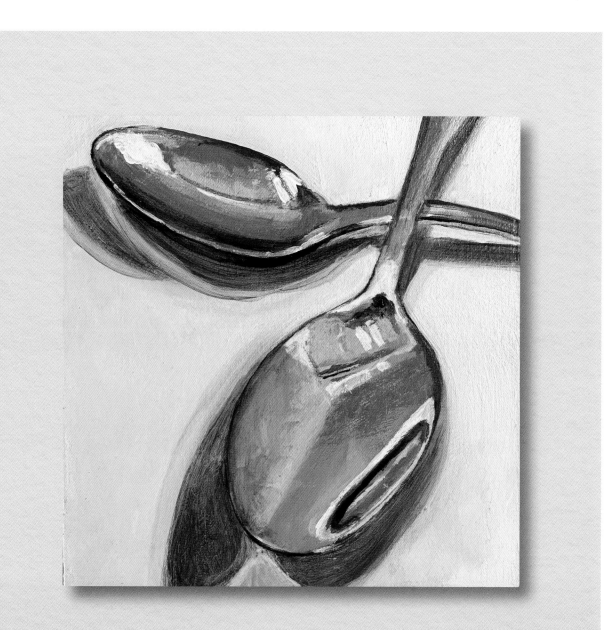

Pay attention to what
is around you as the
reflections are picked up
within the shiny metal
of the spoons.

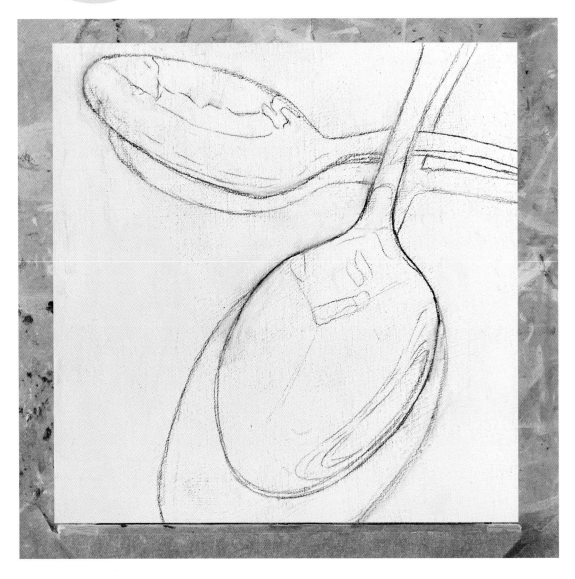

1. UNDERDRAWING

Using a graphite or colored pencil, draw the outline
of the spoons and their cast shadows. You may also
choose to include some of the shapes created by
highlights or other shifts in value.

2. APPLY A WASH

Use a 1-in (2.5-cm) flat paintbrush to apply a wash made up of glazing medium and a bit of Cobalt Blue. This transparent wash will allow the drawing to show through.

TIP

You can use any color for your wash. If you prefer to keep it neutral, try Burnt Umber or Ivory Black (which creates a gray). You don't want to add any white to your wash because white will make the paint more opaque and the goal here is transparency.

3. PAINT BACKGROUND

To mix the background color, start with Lemon Yellow and add a dot of Titanium White. This will help increase the opacity of the color. To darken the color slightly, add a dot of Yellow Ochre.

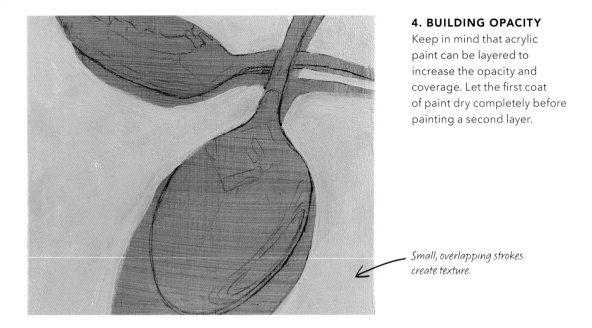

4. BUILDING OPACITY

Keep in mind that acrylic paint can be layered to increase the opacity and coverage. Let the first coat of paint dry completely before painting a second layer.

Small, overlapping strokes create texture.

TIP

Acrylic paint will often appear slightly darker when dry. If you want to adjust the background color, making it either lighter or darker, now is a good time to do that before moving on.

5. CAST SHADOW

To create the color for the cast shadow, start with your background color and add more Yellow Ochre to darken it. This will provide a base coat for the cast shadow; later on you can glaze in color variations and reflections.

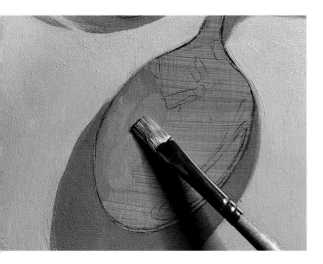

6. BLOCK IN THE SPOONS

Mix a base of Titanium White with a dot of Ivory Black and a dot of Cobalt Blue to create a medium gray. Use a size 6 round brush to start painting in the midtones. You'll work between the different values, going back and forth between light and dark due to all of the variations in value.

7. VARIATIONS IN VALUE

Notice areas where the value is darker and adjust by adding more black paint. For areas where it's lighter, add a bit more white paint. Working wet on wet will allow the values to softly shift. If the paint dries before you can achieve a soft edge, apply more of the first value and then add in the second value.

TIP

Squint to see the subtle shifts in values more easily.

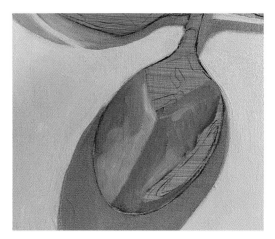

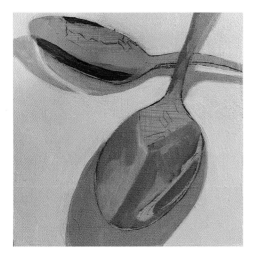

8. DARKER VALUES

You can work back and forth between the two spoons. To make the darker values, add some more Ivory Black to the paint mixture. Look for the shapes of dark values and paint them in, following the curve of the spoon. This will make the spoon appear more dimensional as you layer the different values of paint. You can start to block in the handles of the spoons as well.

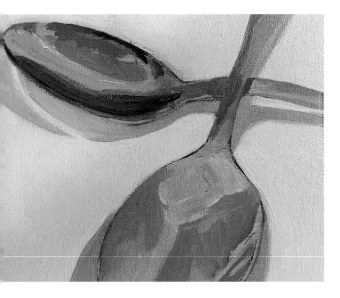

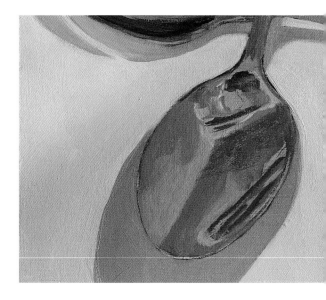

9. LAYERING

Continue to build layers of paint, looking for the different values. If the paint dries and you notice that the value is off, feel free to adjust it.

10. SMALLER SHAPES

Notice some of the smaller shapes. These are observed on the spoon closest to the viewer, where small darker lines and lighter lines make up some of the reflections on the spoon.

TIP

Part of painting is simplifying and creating a slightly abstract version of what we see. Many painters enjoy experimenting with changing colors, exaggerating cast shadows, or expressive brushstrokes. Have fun, and remember it's all part of the learning process.

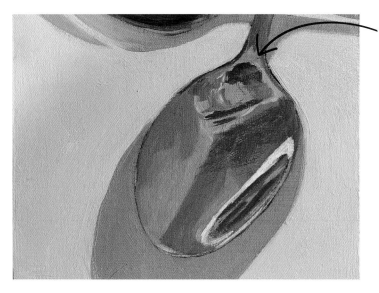

The wash is poking through here.

11. LIGHTER VALUES

As you are blocking in, begin to add some of the lighter values that you can see. Use your size 1 round brush to paint these smaller lines and shapes.

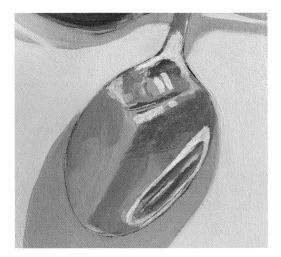

12. ADDING HIGHLIGHTS

Add the highlights near the bottom of the spoon in the front. Notice how there is an area of highlight near the base of the handle. Use your size 1 or size 0 round brush for these smaller lines.

13. CONTINUE TO BUILD

Painting is all about building and layering. As you continue to block in, look for the different areas of light values, medium values, and dark values and make adjustments as needed. You may notice some values appear to sit more "on top." Those are the areas that you'll want to paint last.

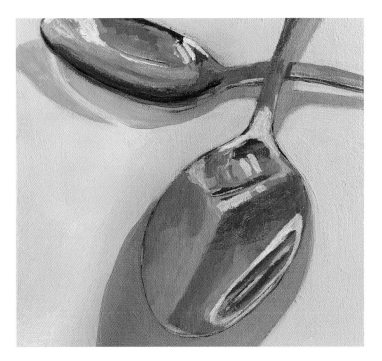

TIP

If you are unsure whether the tone you mixed is accurate enough, paint a little bit of the color onto a strip of white cardstock and hold the strip close to your object. This will help you decide if the color needs adjusting.

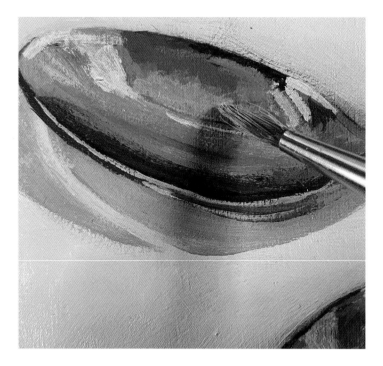

14. SCUMBLE IN HIGHLIGHTS

On the back spoon there is a highlight area near the middle top. Use a bit of white paint and the tiniest dots of black and Cobalt Blue to make a light gray. Use your size 6 round brush to scumble the paint on the spoon (see page 28). This will create a soft, smooth texture.

15. PUSH DARK VALUES

Observe the spoons and consider where you could push the values darker.

TIP

You can let a layer of glaze dry, then layer another one on top to darken it. Layer as many as you'd like until you get the cast shadows as dark as you want them to be.

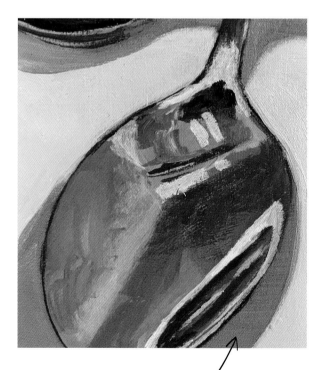

Glazing makes acrylic paint thinner and more transparent.

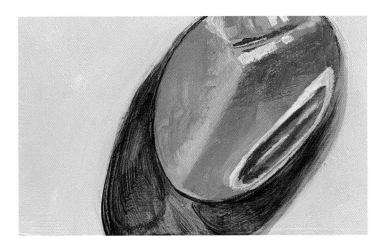

16. GLAZE THE CAST SHADOWS

Mix some Ivory Black with a glazing medium to create a transparent paint. Glaze the paint in the cast shadow of both spoons using a size 6 round brush.

TIP
Remember to step back frequently and observe your painting from a distance. Moving back from your work is important, so you can see your painting from a viewer's standpoint.

17. REFINE AND ADJUST

Look around the painting for areas that could be refined. Use your smallest brushes to add fine details. Double-check your highlights, making sure there are a couple of areas that have pure white. You can adjust as much as you need to until you are satisfied with your painting.

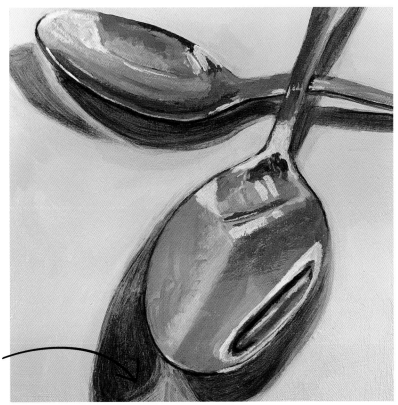

Some of the original background color was glazed into the cast shadow for the lighter areas.

GREEN BUD VASE

I have always enjoyed painting glass and watching it come together, brushstroke by brushstroke. Colored glass is a fun subject to paint because it allows you to play with both color and transparency. Although it can seem intimidating, once the process is broken down, you'll start to see all of the reflections and transparent areas as lines and shapes—this makes the process feel more achievable.

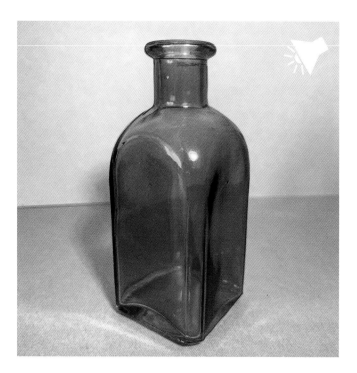

PAINT COLORS

☐ Titanium White
▨ Yellow Ochre
■ Phthalo Green
■ Alizarin Crimson
■ Ivory Black
■ Burnt Umber

TOOLS AND MATERIALS

☐ Wood panel (5 x 5in/13 x 13cm) primed with white gesso (see page 16)
☐ Graphite or colored pencil
☐ Eraser
☐ Ruler
☐ White gesso
☐ Fixative spray
☐ Small palette knife
☐ Palette
☐ Container of water
☐ Paper towels
☐ Glazing medium (optional, can use water)
☐ 1-in (2.5-cm) flat brush (for wash)
☐ Flat brush (size 8)
☐ Round brush (sizes 0 and 6)

SET-UP

Place the green vase on a tan-colored piece of matboard with a cream-colored piece behind it. Position a directional light source coming from the upper right, slightly from the front. Move the light around to experiment with the cast shadows on the vase. Observe the light reflections on the ground as well as on the vase itself.

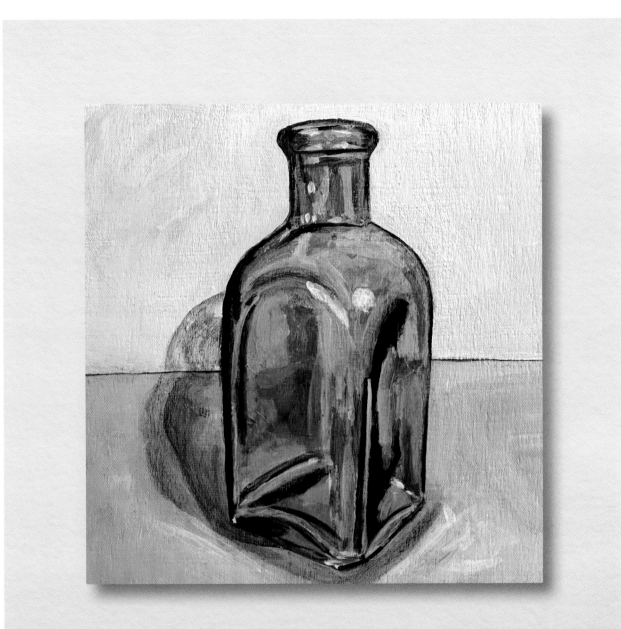

Adding a small amount of glazing medium makes the paint more transparent, allowing the background to poke through.

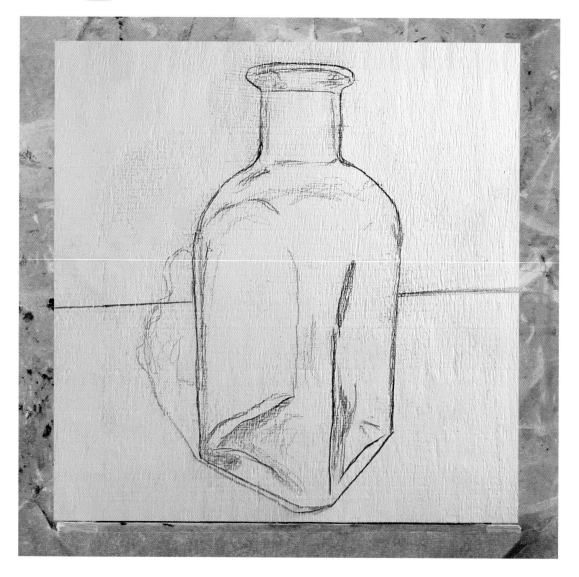

1. UNDERDRAWING

Using either a graphite or colored pencil, draw the outline of the vase and its cast shadows. Look at the other lines and shapes you notice. I typically include the most prominent ones in my drawing, although it's up to you how much you want to include since you can add more details when you begin painting. When you are finished, fix your drawing.

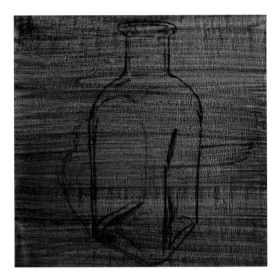

2. APPLY A WASH

A wash provides a middle value, which allows you to easily paint light or dark values on top. I used Alizarin Crimson to complement the green of the vase, but you can use any color you like. Dip the tip of a 1-in (2.5-cm) flat paintbrush in the paint and then dilute it with about 25 percent water, blotting it on a paper towel so it doesn't drip. Test out the transparency of the wash in the negative space. Once it's transparent enough, cover the entire surface and let it dry.

TIP

With acrylic paint it's safe to add a small amount of water without breaking down the binder. If you prefer not to use water, you can create a wash by mixing your acrylic paint with some gloss or matte medium. (Most paint manufacturers will let you know how much water is safe to add to your paint.)

TIP

If you prefer to paint the object first, skip ahead to those steps and return to paint the background when you are finished.

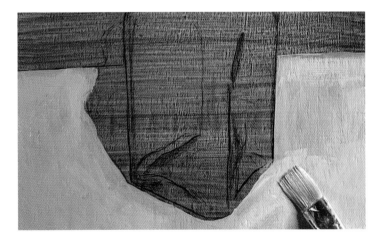

3. PAINT BACKGROUND

Although it's not a requirement, working back to front often makes a lot of sense when painting still-life objects. This is especially true for glass, as some of the background will make its way into the object due to its transparency. Using a size 8 flat brush, block in a mix of Titanium White with a touch of Burnt Umber and Yellow Ochre. Allow the mixture of the colors to vary slightly for a more expressive feel.

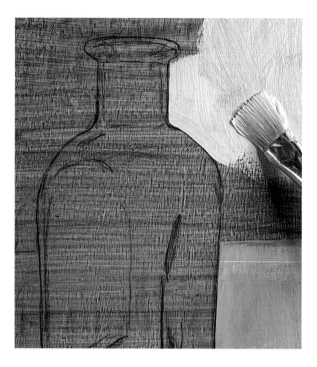

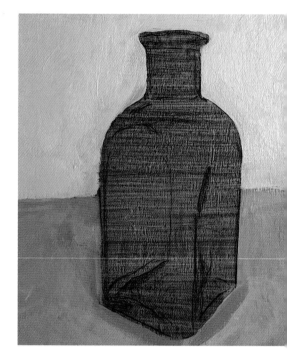

4. PAINT THE WALL COLOR

The wall color is Titanium White mixed with touches of Yellow Ochre and Burnt Umber. Using a size 8 flat brush, block in the color. Keep in mind that acrylic paint requires layers to build up the opacity. Sometimes I will paint the first layer, let it dry, and then come back and add a second layer.

5. CAST SHADOWS

Next, add a slightly darker version of your ground color to the cast shadows. You can darken it by adding a bit more Burnt Umber to the paint mix. Use a small round brush to fill in the shapes created by the cast shadows.

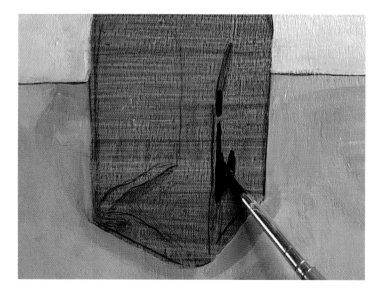

6. DARKEST VALUES

Once you have finished painting in the background, it's time to block in the darkest values on the vase. I used Ivory Black with just a dot of Phthalo Green. Using a small round brush, add in the shapes created by the darkest values.

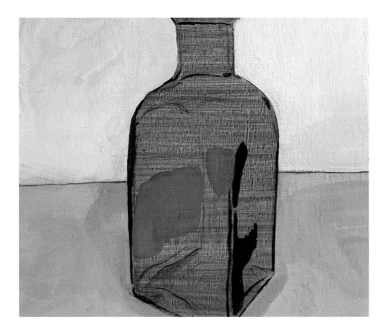

7. MIDDLE VALUES

After blocking in all of the darkest values, you can start to block in the different middle values. As you observe the vase, you will notice several variations of green that fall into the middle value range. Choose one to start with and gradually add in more, looking closely at the shape each color creates and painting it as you see it. Don't worry if it's not exact—part of the fun is creating an expression of what you see.

8. RANGE OF VALUE

Continue to work with a range of values, squinting at the reference to blur out the details and make it easier to see the contrast between values.

Layer shapes in the variations of greens that you see.

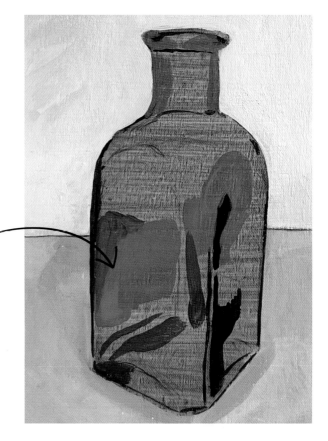

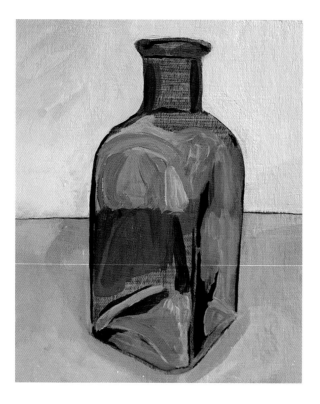

9. BLOCKING IN

Continue to block the greens within the vase. You can hop back and forth between lighter and darker values of greens. Paint can be layered and you can allow edges to overlap. You can also move around the object while the paint dries, then return to adjust the color or add another layer.

10. LIGHT VALUES

Use a round brush to block in the lightest values within the vase. Follow the same process as you did for the dark and medium values, searching for the shapes formed by the colors.

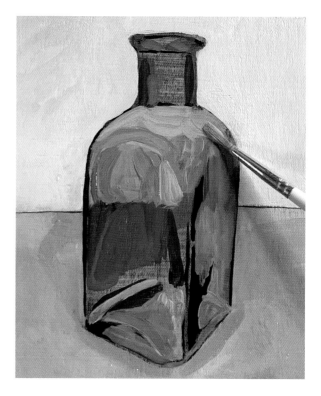

11. DEFINING EDGES

Use a size 0 round brush to define the edges of some of the smaller details.

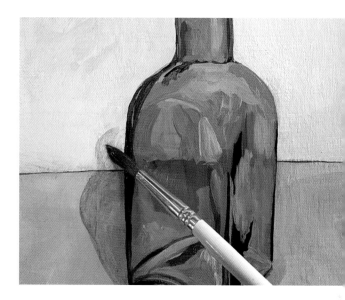

12. CAST SHADOW

Use a size 6 round brush to glaze in the cast shadow behind the vase. I like to use a glazing medium, but water can also work. This will make the paint more transparent, allowing the background color to poke through.

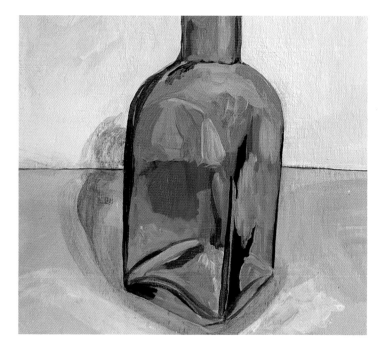

13. REFLECTIVE LIGHT

Add the reflected light in front of the vase using Titanium White mixed with a hint of Yellow Ochre and Burnt Umber. Apply the paint very gently to make the edges softer. Lighten a small area within the cast shadow of the vase.

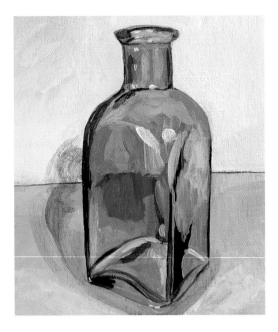

14. HIGHLIGHTS

Save the purest white for the highlights on the vase. This will give a pop of contrast to the overall piece as there are usually only a few areas that are actually pure white.

15. SMALL DETAILS

Add the finishing touches or detail work with your smallest paintbrushes. This includes some of the smaller pops of color. A piece can be as detailed as you want it to be.

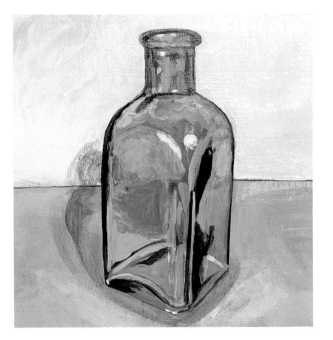

16. STEP BACK

If you step back from time to time, you'll be able to get a better picture of your progress. You'll also be able to see if there are any areas that you want to adjust.

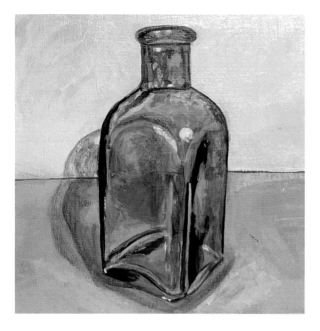

17. PUSHING VALUES

You can mix a bit of glazing medium with some black paint and use a size 6 round brush in order to blend some more shadows into the vase. Add more pure white to the brightest highlights.

18. HIGHLIGHTS

Add more Titanium White with a dot of glazing medium to the reflected light on the ground in front of the vase. This brings a sense of balance to the piece.

The lighter reflections in the front contrast with the darker cast shadows at the back.

STAINLESS KETTLE

Shiny metal objects make for really interesting subject matter because of the reflections they create. When you look closely, you'll notice subtle color variations within the reflections on the kettle. As you begin, you may find it challenging to paint something that is reflective, but once you get going, you'll begin to see reflections as lines and shapes. This makes the process a bit easier.

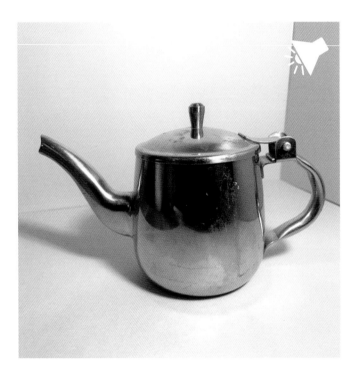

PAINT COLORS

- ▨ Yellow Ochre
- ■ Cobalt Blue
- ■ Ivory Black
- ☐ Titanium White
- ■ Alizarin Crimson

TOOLS AND MATERIALS

- ☐ Wood panel (5 x 5in/13 x 13cm) primed with white gesso (see page 16)
- ☐ Graphite or colored pencil
- ☐ Eraser
- ☐ Ruler
- ☐ White gesso
- ☐ Fixative spray
- ☐ Palette knife
- ☐ Palette
- ☐ Container of water
- ☐ Paper towels
- ☐ Glazing medium (optional, can use water)
- ☐ 1-in (2.5-cm) flat brush (for wash)
- ☐ Flat brush (size 8)
- ☐ Round brush (size 0)

SET-UP

Place the stainless-steel kettle on white matboard with a directional light source coming from the upper right. Move the light around to experiment with the reflections on the metal. Observe the subtle pops of color that you can see within the metal. If you want even more color in your reflections, try using a piece of colored matboard.

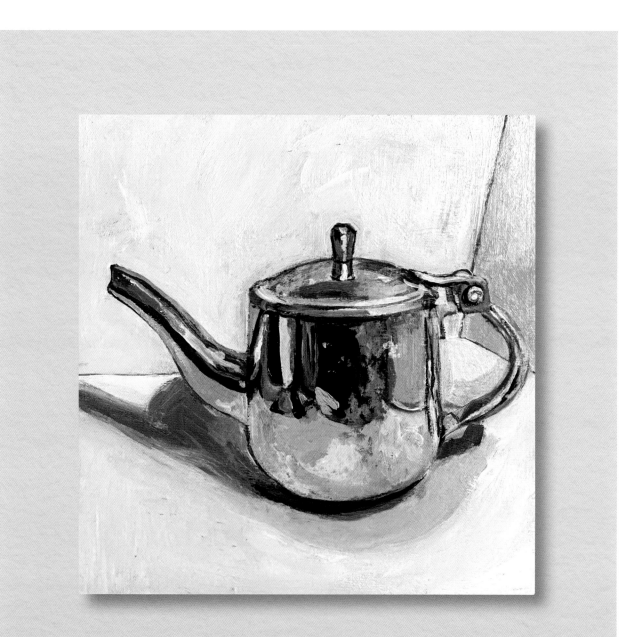

Increase the intensity of the colors within the reflections to elevate the mood of your painting.

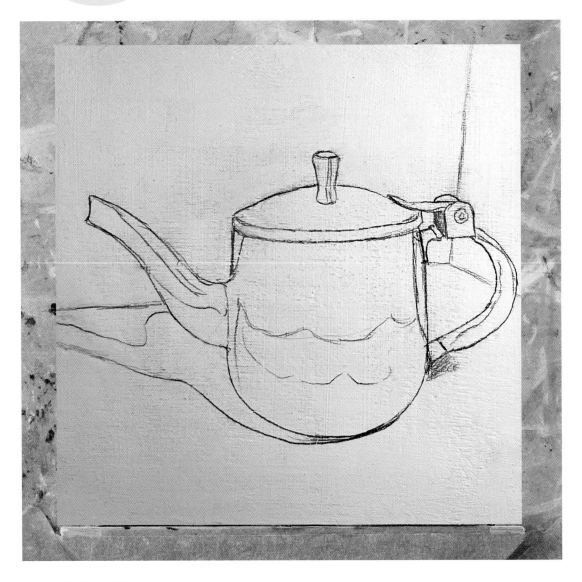

1. UNDERDRAWING

Using either a graphite or colored pencil, draw the outline of the kettle and its cast shadows on your prepped surface. When you are finished, fix your drawing with the fixative spray.

2. APPLY A WASH

Apply a Yellow Ochre wash with a 1-in (2.5-cm) flat paintbrush to give your painting a warm feeling. Let the wash dry completely before moving on.

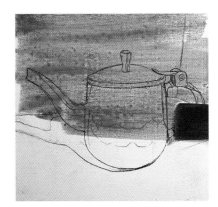

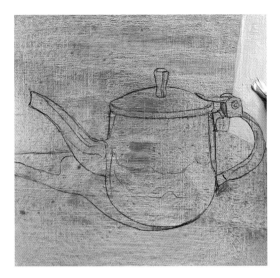

3. BLOCK IN THE BACKGROUND

Using a size 8 flat brush, block in the background in a medium gray mixed from Titanium White with a bit of Ivory Black added in.

4. FINISH THE BACKGROUND

Continue to work on the background and block in the opposite side. This time, it's a lighter gray, so use a bit less Ivory Black in the mixture.

Move brush in multiple directions to avoid harsh directional strokes.

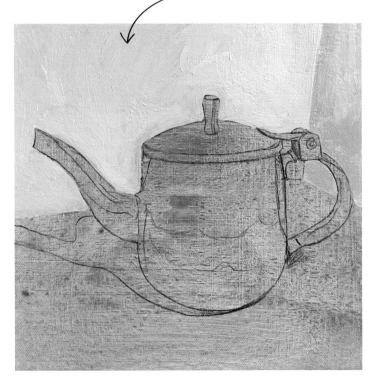

TIP

Sometimes you may need to layer your paint to build opacity. Let the first layer dry and then paint a second layer.

5. THE GROUND

After painting the background, add a thin line of dark gray using a size 0 round brush. Paint the ground a light gray, leaving the cast shadow blank for now.

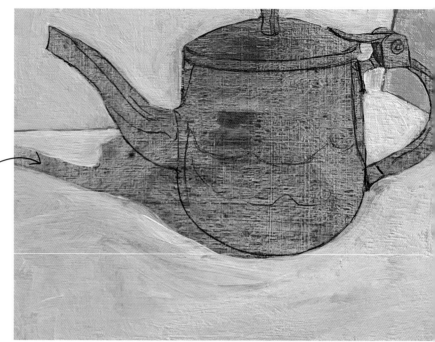

A dramatic cast shadow makes a simple composition interesting.

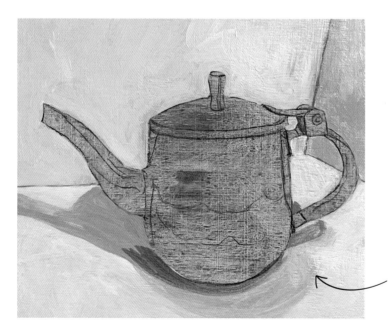

TIP

Squint at the object and shadows to blur the details and see the value structure.

Soft blend between the different values of grays.

6. CAST SHADOWS

After painting the ground, fill in the cast shadows with various middle value grays. You can adjust the ratio of white to black to achieve a range.

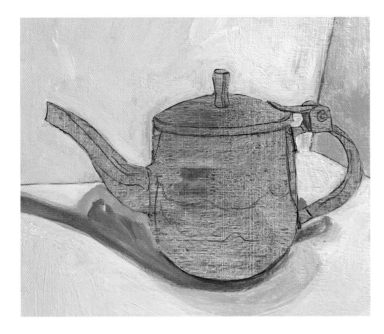

7. BLENDING

Using the wet-on-wet technique (see page 26), blend the grays within the cast shadows to soften the edges.

8. LAYER AND BLEND

With acrylic paint it can be helpful to build up layers to achieve a smoother blend. Use a size 8 flat brush to gently bring the layers of gray together in a soft blend, or you can leave some of the brushwork visible if you prefer.

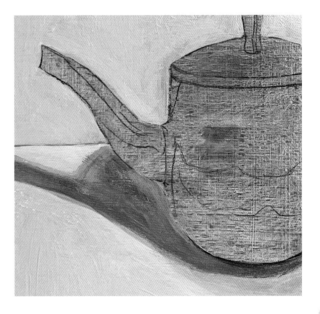

TIP

You can always make adjustments as needed. Once the paint has dried, assess the value compared to your reference. Acrylic paint has opaque coverage, so you can make something lighter just as easily as you can make something darker.

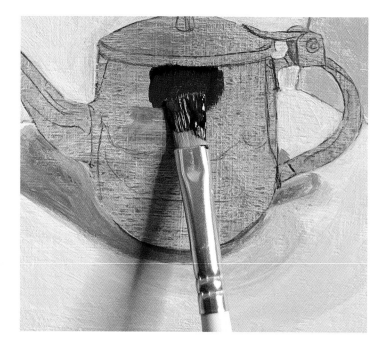

9. DARK VALUES

Next, use a size 8 flat brush to start blocking in the darkest values on the kettle. Once again, I find squinting to be a helpful tool for seeing the contrast in values. Look for shapes within the reflections and always keep in mind that you don't have to paint everything you see.

10. MIDDLE VALUES

After blocking in the darkest values, work toward blocking in the middle values. Go back to the darker values and make adjustments as needed—it's all part of the painting process. You'll want an overlap of brushstrokes and colors, which involves working back and forth between values at times.

TIP

Though it's not necessary, it can be fun to let areas of the wash poke through.

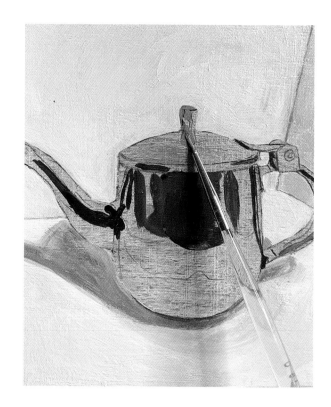

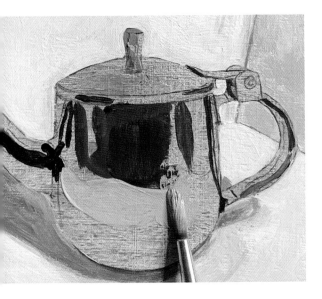

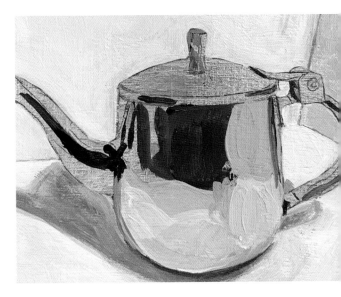

11. SEEING A RANGE

Look for shapes within the values. You'll notice that a lighter value next to a darker value will naturally form a line. Thicker areas of value often read as shapes. Use this method as you continue to block in the values. Remember you can always adjust values as needed.

12. BLOCKING IN

Squint at your references to see the values and continue to block in. It's okay to switch back and forth between values to create a layered effect in your painting.

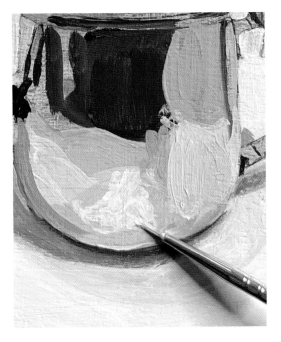

TIP

Darker values tend to go back in space while lighter values come forward. When you start to add both to your painting, you'll create a sense of depth.

13. HIGHLIGHTS

Using a size 0 round brush, add some of the lightest values within the kettle. Move your brush around in a gentle, circular motion to create a softer application of paint. This is often referred to as scumbling (see page 28).

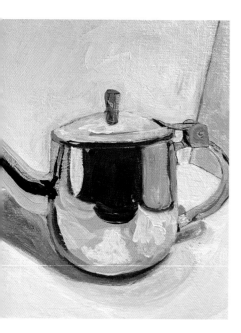

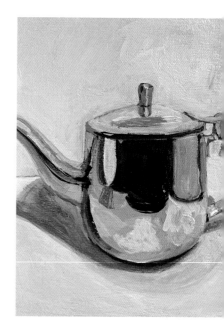

14. BUILDING UP LAYERS

As you work around your painting, continue to look for differentiation in color and value. It's okay to go back and forth between lighter and darker values. Continue to make adjustments as needed.

15. SMALLER AREAS

After blocking in the larger areas of value, start to fill in some of the smaller areas using a size 0 round brush. Glazing medium can be added to create more transparent reflections.

16. STEP BACK

Remember to step back and assess your work, making adjustments as needed. Continue to fill in any open areas within the painting.

TIP

Not every single detail has to be captured in your painting. You can focus on the details that stand out to you. Still-life painting ranges from hyper realistic to fully abstracted, with a wide spectrum in between.

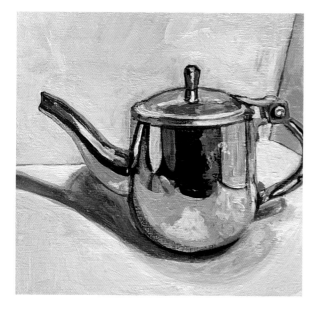

17. COLOR REFLECTIONS

Looking at the reflections on the kettle, you'll notice some warm reds and cool blues. Mix Alizarin Crimson or Cobalt Blue with Titanium White to get the color for these reflections.

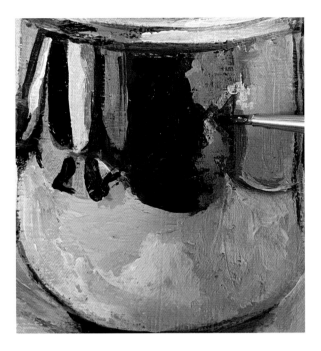

18. DETAIL WORK

Small, detailed brushwork can be some of the most transformative, truly making your piece come together. Here, I am using medium gray on a size 0 round brush to tap in some texture on top of some of the reflections.

Push darker values on the kettle lid with a small brush.

19. PUSHING VALUES

Before I decide I am finished with a painting I push a few of the values, especially making dark values a bit darker and highlights a bit brighter. This creates a sense of depth by including a full range of value.

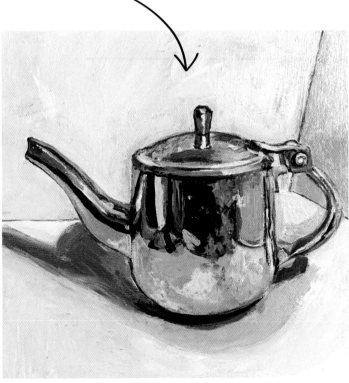

Glossary

Cast shadow is created when an object obstructs the light. It is made of several other depths of shadow. See also Penumbra and Occlusion shadow.

Color shift refers to paint darkening as it dries. This is due to the binder changing from white to transparent as it dries.

Core shadow is the darkest shadow that can be seen on an object, benefiting from neither direct light nor reflected light.

Fixative spray is a colorless spray used to "fix" underdrawings in graphite, pastel, or charcoal to stop them from smudging.

Gesso (pronounced "jesso") is used to prime surfaces (e.g. canvas or wood), creating a stable ground to paint on and acting as a seal between your paint and the surface beneath. Applying gesso will help prevent the porous surface from absorbing the paint.

Glazing is a technique where a thin layer of paint (made transparent by mixing it with a medium) is painted on top of an existing layer of dry paint.

Grayscale refers to the sequence of tones between white and black. Visualizing your subject in black and white helps to assess the values of all your colors and ensures that you have strong contrasts from highlights to shadows.

Ground is the layer used to prepare a support for painting; its color and tone can affect the chromatic and tonal values of the paint layers applied over it.

Highlight is the lightest and brightest value, where the light source hits the object directly.

Impasto is a way of "sculpting" with paint using anything from a brush, a palette knife, or your fingers, or even by squeezing paint directly onto the surface from the tube. It brings texture and dimension to your painting.

Local color is an object's overall color as you actually see it (and not what you think the object's color is).

Medium refers to a particular type of art (e.g. painting, sculpture, printmaking, etc.) In acrylic painting, medium usually refers to a substance that can be mixed into the paints to manipulate them (e.g. make the paint thinner or thicker, make it stay wet longer, increase transparency).

Midtone is in the middle of the tonal spectrum.

Occlusion shadow is the darkest shadow in your painting, usually to be found within the cast shadow.

Palette is either the range of paints you have chosen or a surface on which to mix paints.

Penumbra is the outer edge of a cast shadow.

Pigment is pure color, usually mixed with acrylic polymer as a binder.

Priming makes your surface/substrate ready for painting (with acrylic gesso or another type of primer).

Reflected light on an object is caused by light bouncing back from the surface upon which it rests.

Saturation (also referred to as chroma) describes a color's intensity and vibrancy.

Shadow box is a still-life set-up that is the best way to ensure consistency of light and shadow while you work on your painting.

Tone (also referred to as Value) describes how light or dark a color is.

Trompe l'oeil means "deceives the eye" in French. In painting, it means creating the illusion that the subject of the painting is "three-dimensional" and real.

Value (also referred to as Tone) describes how light or dark a color is.

Viewfinder is a device that can be used to help crop your view and check the composition of your set-up.

Index

Projects are in **bold**.

Acknowledgments

I would like to first and foremost thank the wonderful team at Quarto for their guidance and support throughout the process of writing this book. I couldn't have done this without you, Ella!

I would like to thank my dear friend, Annie, for putting the thought of becoming an art teacher in my head when I was 15. Your encouragement means the world to me. Thank you to Sarah and Mandi for being a source of inspiration and support.

Thank you to my family and friends for always believing in me.

Recommended Reading

Acrylics for the Absolute Beginner by Charles Evans (Search Press, 2017)

Exploring Color by Nita Leland (North Light Books, 1998)

Daily Painting: Paint Small and Often to Become a More Creative, Productive, and Successful Artist by Carol Marine (Watson-Guptill, 2014)

101 Textures in Oil & Acrylic: Practical Techniques for Rendering a Variety of Surfaces by Mia Tavonatti (Walter Foster Publishing, 2013)

Painting for the Absolute and Utter Beginner by Claire Watson Garcia (Watson-Guptill, 2009)